KARL BODMER'S EASTERN VIEWS

A Journey in North America

KARL BODMER'S EASTERN VIEWS
A Journey in North America

MARSHA V. GALLAGHER

JOHN F. SEARS

JOSLYN ART MUSEUM
Omaha, Nebraska

Library of Congress Cataloging in Publication Data

Gallagher, Marsha V.
 Karl Bodmer's eastern views / Marsha V. Gallagher ; with an essay by John F. Sears.
 p. cm.
 Catalogue of an exhibition held at Joslyn Art Museum, Sept. 28-Dec. 1, 1996.
 Includes bibliographical references.
 ISBN 0-936364-26-2
 1. Bodmer, Karl, 1809-1893--Exhibitions. 2. East (U.S.) in art--Exhibitions. I.
 Sears, John F., 1941- . II. Joslyn Art Museum. III. Title.
 ND2010.B58A4 1996 96-32475
 759.9494--dc20 CIP

ISBN 0-936364-26-2

Catalogue of an exhibition at Joslyn Art Museum, Omaha, Nebraska, September 28 - December 1, 1996.

Published by Joslyn Art Museum, Omaha, Nebraska.

All illustrations, unless otherwise indicated, are by Karl Bodmer from the collection of Joslyn Art Museum, Gift of the Enron Art Foundation.

PHOTOGRAPHY: Malcolm Varon, Lorran Meares, P. Drickey
COVER: *View of New Harmony* (detail), watercolor on paper.

Design by Emspace Design + Art Direction; Film by Infinity Graphics; Printing by Barnhart Press
2,500 copies set in Goudy and Caslon Italic

CONTENTS

FOREWORD

*T*he Maximilian-Bodmer Collection at Joslyn Art Museum is internationally recognized as a priceless record of early nineteenth-century America. Nebraska is fortunate to have this significant collection, which has achieved a broad audience through numerous publications and exhibitions. On loan to Joslyn for a number of years, the entire collection was gifted to the Museum in 1986 by the Enron Art Foundation.

Prince Maximilian's meticulous written observations, contained in lengthy journals and letters, are beautifully depicted by hundreds of landscapes and portraits created by Karl Bodmer. The studies they made of the upper Missouri frontier have been widely praised as an incomparable account of the native peoples and lands of the Plains.

Far less recognition has been given to Bodmer's works portraying the eastern half of the then-young United States – detailed scenes of new, growing towns and of settlements on the edges of a rapidly shrinking wilderness. Maximilian's accompanying narrative identifies many of the details and reinforces the sense that we're looking at history. It's a rare privilege and one we're pleased to share with you through this extraordinary exhibition and catalogue.

Walter Scott, Jr.
Chairman, Board of Governors

ACKNOWLEDGMENTS

*W*ithout the incomparable resource known as the Maximilian-Bodmer Collection, this exhibition and catalogue would not have been possible. The collection consists of nearly 400 drawings and watercolors by Karl Bodmer; multiple copies of the prints produced by Bodmer to accompany the German, French, and English editions of *Travels in the Interior of North America, 1832-1834;* Maximilian's manuscript journals and correspondence related to the expedition and to the production of the later publications; as well as a wealth of ephemera, ranging from contemporary newspapers, maps and broadsides to bills and social invitations. This North American expedition material was kept in the Wied archives at the family estate in Neuwied for nearly a century after Maximilian's death in 1867. In the 1950s a selection of the watercolors was shown at various venues in Germany and the United States, and in 1959 the entire collection of art and archival material was sold to M. Knoedler and Company in New York. Northern Natural Gas Company, an Omaha corporation, purchased it from Knoedler in 1962 and placed it on long-term loan at Joslyn Art Museum; in 1986 Enron (the successor of Northern Natural Gas) generously gave the collection outright to the Museum. If not for the vision of John F. Merriam, chairman in 1962 of both the Joslyn governing board and the corporate board of Northern Natural Gas, and the then director of Joslyn, Eugene Kingman, the collection might not have remained intact. The corporation also established the Center for Western Studies at Joslyn in 1980, a curatorial department devoted to the interdisciplinary interpretation of Western art, history, and ethnography. The Center is now supported by an endowment, initiated by a 1992 challenge grant from the National Endowment for the Humanities and being completed through matching funds provided by many contributors, whose gifts are greatly appreciated.

Karl Bodmer's Eastern Views required the support of many colleagues. John Sears, catalogue essayist, joins me in giving particular thanks to Paul Schach, Professor Emeritus of Germanic Languages at the University of Nebraska-Lincoln, for sharing his expertise on Maximilian's manuscripts and career. Jean Lee, Curator at New Harmony State Historic Site, provided valuable information about that site at the time of Maximilian and Bodmer's sojourn there. Graham W. J. Beal, former Director of Joslyn (April 1989-June 1996), encouraged the development of the exhibition and accompanying catalogue. Other staff members provided invaluable assistance in the myriad responsibilities entailed in planning, installing, and travelling the exhibition, and in researching, editing, and producing this publication. Particular appreciation is due to Theodore W. James and the Collections and Exhibitions Department, who ably managed the preparation of the exhibition; to Katey Brown and Education Department personnel, for thoughtful editing and program development; and to Kathryn Corcoran and the Library staff, for tireless research on topics large and small. The combined, dedicated efforts of Linda Rajcevich, Director of Marketing and Public Relations; Ruby C. Hagerbaumer, Curatorial Assistant; and Larry K. Mensching, Center for Western Studies Administrative Assistant, are largely responsible for the timely production of this catalogue.

Finally, warm thanks are due to the Joslyn Art Museum Association, Omaha for their financial support of the presentation of *Karl Bodmer's Eastern Views* at Joslyn. The show and the catalogue will bring deserved recognition to a special segment of the renowned Maximilian-Bodmer Collection.

Marsha V. Gallagher
Chief Curator, Joslyn Art Museum

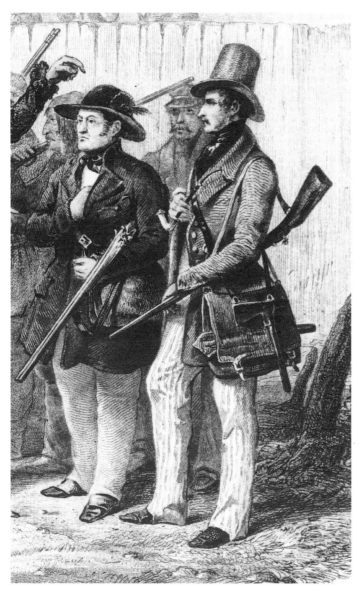

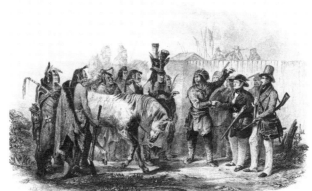

1 after Karl Bodmer, *The Travellers Meeting with Minatarre* [Hidatsa] *Indians near Fort Clark,* engraving with aquatint, hand-colored.

This detail of one of the 81 prints produced to illustrate Maximilian's published account of his North American journey is the only known image of Maximilian and Bodmer at the time of the expedition. Bodmer stands at the right, the Prince beside him in dark coat and hat. They are being introduced to a delegation of Hidatsa Indians at Fort Clark on the upper Missouri in 1833.

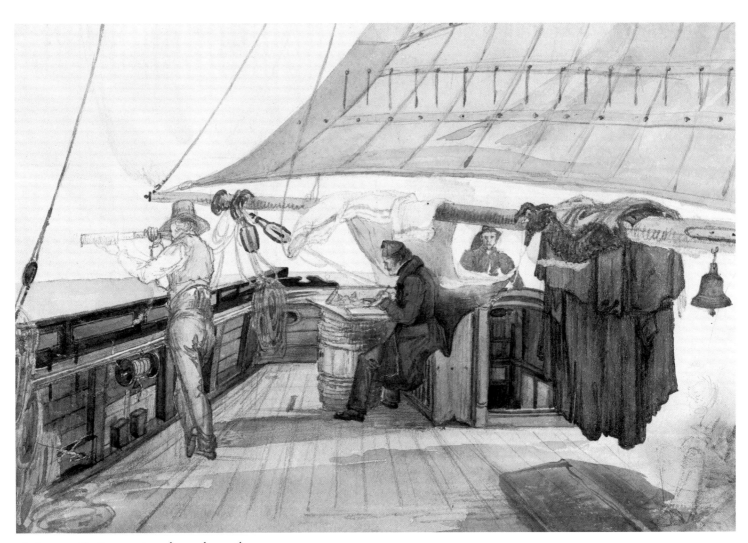

2 *Scene on the Janus,* watercolor and pencil on paper.

TRAVELS WITH MAXIMILIAN:
Karl Bodmer's Journey in North America

by Marsha V. Gallagher

Koblenz, February 25, 1832.

"Serene Prince. . . . I forward to your Highness herewith the sketches I received today from the young master artist. . . . They show . . . his artistic talent and how much can be expected from him for our purpose." The writer, an officer in the Prussian army, went on to assure the Prince not only of the artist's ability to sketch accurately from nature, but also that *"this healthy twenty year old . . . would like very much to participate in the journey and since he is not demanding* [and is] *able to stand the strain and difficulties of such an expedition . . .* [then] *if your Highness considers his talents satisfactory . . . nobody is as apt. . . . What the master lacks so far is a little knowledge of the art of hunting, but that he can learn."*[1]

The individual to whom this letter was addressed was Prince Maximilian of Wied-Neuwied (1782-1867), who was planning an extended trip to explore and document the "natural face of North America."[2] A trained scientist, Maximilian dedicated most of his life to the study of natural history. He undertook his first major expedition in 1815 to Brazil, where he spent two years collecting and describing the flora, fauna, and tribal groups he encountered there; upon his return to his home in Germany he prepared an extensive summary of his findings, which was published in 1820-21 as *Reise nach Brasilien in den Jahren 1815 bis 1817*. This was illustrated with engravings based on field sketches by Maximilian: straightforward compositions, meticulously detailed, but somewhat stiff and lacking aesthetic appeal. Perhaps Maximilian recognized this, or perhaps one of his more artistically inclined siblings (he was the eighth of ten children, two of whom were amateur painters) made the suggestion, but for his second major expedition to the New World, he determined to employ a professional artist. His inquiries led him to Karl Bodmer (1809-1893), who had actually turned 23 just before the letter quoted above was penned. A native of Switzerland, young Karl studied water-color and engraving with his uncle, the painter Johann Jakob Meier (1787-1858), before moving to Koblenz in 1828. By 1832 he had already published numerous engravings of the Rhine river- and landscape,[3] and it was likely these that caught the attention of Maximilian's colleague.

A contract was negotiated between the Prince and Bodmer. Aside from his artistic duties, which were to visually record the subjects of Maximilian's written observations, Bodmer would be required to assist in the search for specimens (hence the officer's remark that the artist could be trained to hunt). Maximilian would own the products of Bodmer's labors, which were expected to form an important part of the publication to be produced after their return. The artist's expenses would be paid, along with a modest salary. But the Prince, who carefully managed the funds that supported his research, warned Bodmer that he anticipated that they would live very frugally on their projected two-year sojourn. Bodmer argued with spirit some of the terms ("It is to be understood that the Prince will give me occasionally a few hours to my own disposition if time and circumstances allow" me to sketch for myself[4]), but in the end the two men were in agreement regarding Bodmer's services and compensation.

3 The Brig Janus, pencil on paper.

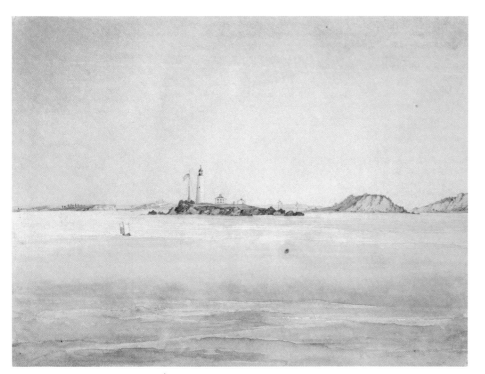

4 Boston Lighthouse, watercolor on paper.

to the high wages there, while others were not – "artists' materials and paper [can] be bought as cheaply in New York or Philadelphia" because taxes on them were too high in Europe.[5] Among the objects included in the travellers' presumably voluminous luggage were custom-made guns (to shoot specimens) for Maximilian, Bodmer, and David Dreidoppel (a Wied family retainer and a skilled huntsman and taxidermist), who accompanied the Prince on his Brazilian expedition and would now trek with him to North America.

Finally, all was ready, and when Maximilian wrote to inform Bodmer of the departure date, he replied that "I shall be with your Highness in Neuwied fully equipped May 6," 1832.[6] On May 7 the trio left Maximilian's family estate there and began to make their way to Rotterdam, from whence they sailed on the American brig *Janus* ten days later. Maximilian dismissively remarked afterward that "voyages to North America [have] become everyday occurrences," but his description of their passage makes it seem anything but commonplace to a modern reader. The forty-eight days from Rotterdam to Boston made for a somewhat longer voyage than anticipated; the last bottle of wine was consumed on the forty-third day, which was especially regrettable in view of the poor quality of the food. Many storms were encountered, several of them unusually fierce. The travellers endured cramped and frequently wet quarters, and suffered from seasickness – particularly Bodmer. When he was feeling well enough, Bodmer sketched some scenes at sea, such as a colorful view of the deck on the *Janus,* the captain at the rail with a telescope, and another figure, likely Maximilian, seated and busily engaged in diary- or other record-keeping *[illus. 2].*

On July 3, the Massachusetts coast was sighted, and the beacon of Boston lighthouse *[illus. 4]* beckoned them ashore. They landed the following afternoon, in the midst of a noisy celebration of Independence Day.

Maximilian was characteristically thorough in his preparations for the journey. He sought from European colleagues letters of introduction to individuals in North America who could assist him in his studies or facilitate his travels. He also asked his friends' advice on worthy destinations, as well as on what supplies he should take with him; some items were evidently more expensive in America, due

In his preface to *Travels in the Interior of North America, 1832–1834,* Maximilian says that "the United States were merely the basis of my more extensive undertaking, the object of which was the investigation of the upper . . . Missouri" frontier. He declared that the States therefore did not "form a prominent feature" of his research, and added that "it is impossible to expect, from a few months' residence, an opinion on the social condition and character" of such a widely varied land and people. Yet Maximilian's experiences in the eastern half of this burgeoning country, from the Atlantic seaboard to St. Louis, occupied nearly half of his two-year stay and one-third of his three-volume diary; just over one-third of the Bodmer sketches and paintings at the Joslyn Art Museum (the largest holdings extant) are eastern in subject. Together they form a significant body of work, a narrow but unique window on a vast and rapidly changing new nation.

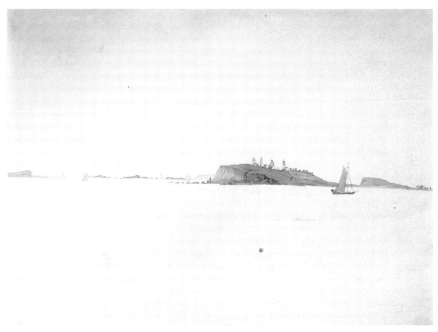

5 *Telegraph Hill, Boston,* watercolor on paper.

Boston at that time was "an extensive city, with above 80,000 inhabitants," architecturally reminiscent of English towns, and filled with numerous elegant shops purveying all manner of merchandise – although Maximilian bemoaned the lack of publications on the aboriginal populations he was so eager to know more about. Intent on visiting local sites of interest, the men went on July 6 to a monument, then under construction, memorializing the Revolutionary War battle at Bunker Hill. Originally intended to be built 210 feet high, the plan had been reduced to 180, and the structure was at present only 50 to 60 feet tall. Maximilian nevertheless lauded the view from the roof (reached by an interior staircase), which offered an "incomparable" vista "over the city of Boston, Charlestown, . . . [and] the Bay of Boston." Bodmer's rendering of the scene *[illus.6]* shows lofty spires in the distance, and tumbled building blocks of granite at the base of the monument. If Maximilian was favorably

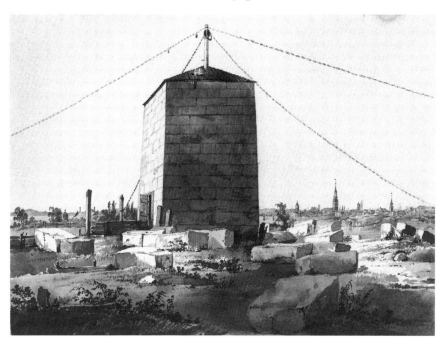

6 *The Bunker Hill Monument,* ink and wash on paper.

impressed by the numerous excellent institutions in the Boston area, he was ambivalent about the current clothing fashions and uncomplimentary about the inns, particularly about the meals and the manner in which they were served and eaten. Bells were rung to announce a meal, and guests would rush to the dining room, pushing and shoving their way to the table. "Then everyone takes possession of the dish he can first lay his hands on, and in ten minutes all is consumed;" knives were the principal eating utensil, the two-pronged forks useful only as "a stabbing weapon."

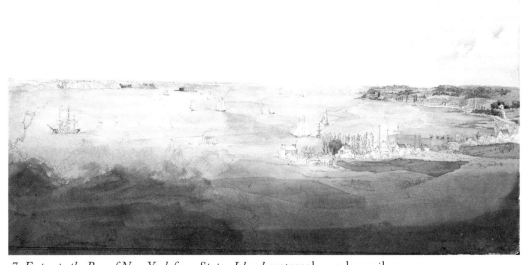

7 *Entry to the Bay of New York from Staten Island*, watercolor and pencil on paper.

From Boston the travellers went by coach to Providence, where they booked passage on a steamboat to the city of New York. While awaiting the arrival of the steamboat they were dismayed to learn of an outbreak of cholera in their destination. An epidemic of the dread disease had spread rapidly earlier that summer from Canada through the northern states, and now was being reported further south. Maximilian determined to go to New York regardless, but altered his original plan to visit Niagara Falls and the Great Lakes before heading to the western frontier. Among the wealth of ephemera collected and preserved by Maximilian on the North American expedition are several printed documents concerning this epidemic. One, which enumerated over 400 deaths attributed to cholera that year in Albany, New York, stated grimly that despite numerous studies and speculations, "the learned are still at variance, and the world is yet unenlightened" as to "whether this . . . disease is atmospheric or telluric in its origin, or endemic, epidemic, infectious, contagious or non-contagious in its nature."[7] A public poster printed in Cincinnati warned individuals to "attend, instantly, to the first symptoms [and] go to bed, drink hot water or tea, promote a perspiration, and send

for their family Physician." All those "who neglect this [early] stage [of the disease], are in danger of perishing."[8] Maximilian had good reason to be concerned for the health of himself and his companions.

The Prince described New York as "but little inferior to the capital cities of Europe, with the exception of London and Paris . . . [with], at present, 220,000 inhabitants . . . [and] commerce . . . so extensive, animated, and active, that in this respect it is scarcely surpassed by any." Maximilian and Bodmer arrived there on July 9 (leaving Dreidoppel behind to await the belated delivery of most of their luggage from the *Janus*). The Prussian consul introduced Maximilian to the German community in New York, and invited him to stay for a few days at his country home in Bloomingdale; among the nearby sights of interest was a large insane asylum, which Maximilian toured with its resident physician. He pronounced it an "excellent establishment," and commended New York for its "many such useful institutions – hospitals, poorhouses, and houses of correction, in which latter

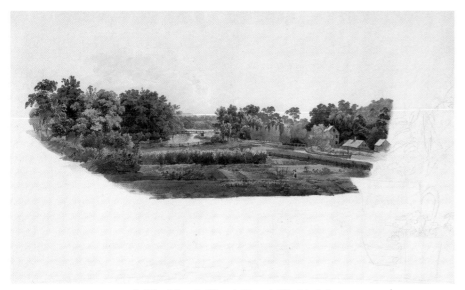

8 The Mauch Chunk Canal: Woehler's Inn, watercolor on paper.

populated areas where such variety would be harder to come by.

In Boston and New York Maximilian had sought out museums, which disappointed him as jumbles of generally unlabeled "specimens of natural history, . . . awkward wax figures, mathematical and other instruments, models, [and] bad paintings and engravings." The Peale Museum in Philadelphia he found to be exceptional both for the variety and importance of its natural history collection, and for "its more scientific arrangement." He noted particularly some paintings of Native American scenes by Samuel Seymour who, along with Titian Peale, the Museum's proprietor, had accompanied Major Stephen Long on an 1819-20 expedition to the West; Maximilian found the paintings interesting in subject matter but mediocre in execution, doubtless comparing them to Bodmer's greater skills in draftsmanship.

On July 28 Bodmer and Dreidoppel joined Maximilian in Philadelphia (still without the lost baggage, however) and two days later the men set out by crowded stagecoach (there were six other passengers) for Bethlehem, which Maximilian had previously identified as a suitable location to begin in earnest his natural history studies. The town was then "no more than a village, but [was] rapidly increasing, . . . [with many] streets," and a stately church that figures prominently in Bodmer's broad view *[illus. 80]*; a large building with a dormered roof close to the church may be the Young Ladies Seminary, run by Reverend Charles Seidel, who befriended Maximilian. The seminary offered schooling in standard subjects for $28.00 per quarter, and "Instruction in Music, French, Drawing, Painting on Velvet, Ebony-Work, Ribbon-Work and Worsted-Work," for an extra $3.00 per class per quarter.[10] Maximilian complimented Bodmer for the detailed accuracy of his depiction of Bethlehem, and noted that the viewpoint was from the nearby vineyards owned by their innkeeper, Henry Woehler, a scene also recorded by the artist *[illus. 8]*.

the young, who may still be reclaimed, are not mixed with the old, hardened offenders, but are kept apart." The Prince soon became restless, however, being eager to proceed with his journey. On July 16 he set out, by steamboat and stagecoach, for Philadelphia. Bodmer stayed behind, to wait for Dreidoppel, and to finish a view he was working on, perhaps the one of New York harbor from Staten Island *[illus. 7]*; a more detailed version of this later became the basis for an illustration in *Travels in the Interior of North America, 1832-1834.*

Several of the scientists whom Maximilian wished to see in Philadelphia had no time for him, because, as they were also physicians, they were busy with the developing problem of cholera. But Mr. Krumbhaar, a German "to whom I had letters [of introduction], received me with great kindness, and introduced me to many agreeable acquaintances . . . [and] took me to . . . one of the most interesting spots," a complicated system of reservoirs and machinery that delivered water to the city. Mr. Krumbhaar was an importer and manufacturer of articles connected with the drug business, and the catalogue that advertised his offerings listed paints, brushes, and inks, along with a wide diversity of other items. Maximilian, or Bodmer when he later joined the Prince, may well have purchased art supplies from Krumbhaar, or from a stationer such as R.H. Hobson (who carried "a general assortment of Artists' Drawing Materials, Stationery, and Fancy Articles" [9]), before setting off for less

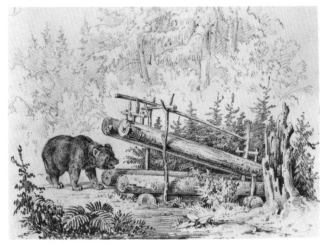

9 Bear Trap, pencil on paper.

Bethlehem became the base for more than six weeks of "excursions in the neighboring country," afternoon walks as well as forays of several days duration, all devoted to the study of the regional flora and fauna. Although the length of their stay was in fact determined by the continued delay in the delivery of their baggage, which contained essential books and equipment, Maximilian felt they made good use of the time, collecting and identifying specimens, and otherwise familiarizing themselves with the Pennsylvania landscape. On one of these side trips the men made a wide circuit, travelling in a light carriage east to Easton, north to the Delaware Water Gap and Mount Pocono, west to Wilkes-Barre, south to Mauch Chunk, and back to Bethlehem. Numerous specimens were collected, principally plants, but a variety of animals as well. Maximilian particularly

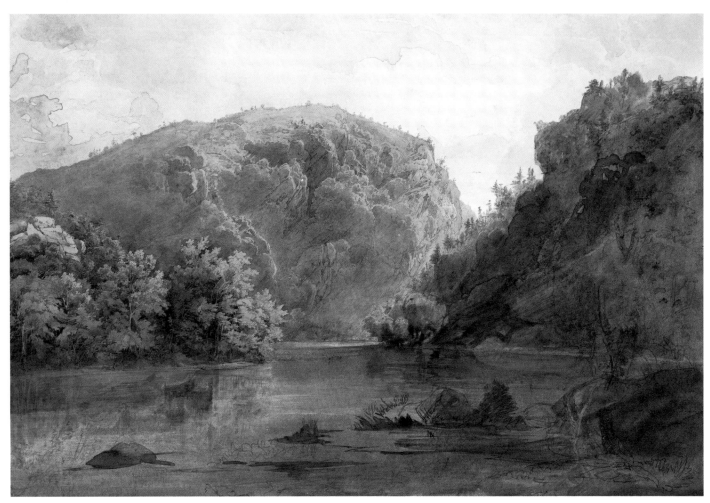

10 The Delaware Water Gap, watercolor on paper.

wanted a rattlesnake and, as these seemed to elude him in the field, he eventually purchased one which had been captured by an innkeeper; it was "a very large and handsome specimen," for which he paid $2.50. He then promptly dispatched it and preserved it in brandy, "as a live creature of this kind is not the most agreeable travelling companion." The Prince, interested in bears, took the party out of their way to see a trap deep in the forest, where a young one had been caught and killed a few days earlier. Bodmer made a drawing of the large deadfall trap, adding from his imagination an inquisitive bear *[illus. 9]*.

Although the scientist's main focus was recording data, he also paused to admire the beauty of the wilderness they passed through. The "savage grandeur of the scenery [was] very striking," especially the "uninterrupted primeval forests" in the Poconos. Bodmer took great care to translate this beauty visually in his studies. He chose his vantage points deliberately, and sometimes, while Maximilian went ahead, the artist stayed behind or returned to an earlier site to finish his work or try an alternate view. Maximilian pronounced these scenes to be faithful to their subjects, from the rugged loftiness of the Delaware Water Gap *[illus. 10]* to a road and bridge made nearly insignificant by the enveloping, towering Allegheny forest *[illus. 11]*.

The Prince eagerly anticipated his visit to Mauch Chunk, "celebrated as the central point of the Lehigh coal district."[11] This time it was modern technology, rather than natural science, that attracted him – he was fascinated by the narrow railroad which had been constructed to deliver coal from the mines to the town. Nor was he the only one. So many people came to see this ingenious device that a rail coach service was established to accommodate them; Maximilian drew a picture of it in his diary *[illus. 12]*, showing the carriage, passengers, and driver. The coal cars, like the passenger carriages, were hauled up the mountain on the rails; on the return, there was no need of horses, for the cars sped down the steep slope "with the rapidity of an arrow," drawn by the force of gravity, controlled by friction brakes. Maximilian was aware of the economic importance of mechanical improvements such as these, noting that, in an era of rapidly increasing consumption, the rail cars delivered 450 tons of coal to Mauch Chunk daily, to be loaded on barges and carried away for industrial and other use.

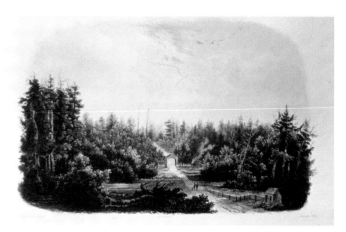

11 after Karl Bodmer, *Forest Scene on the Tobihanna, Alleghany* [sic] *Mountains*, engraving with aquatint, hand-colored.

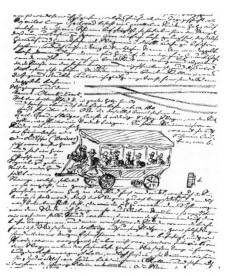

12 Detail, page 85 of Maximilian's *Tagebuch (Journal)*, vol. I.

This page is typical of the Prince's thorough record keeping and representative of his artistic abilities. The top drawing is a detail of a railway lay-by at Mauch Chunk; the larger sketch shows one of the passenger carriages (the driver is equipped with a bugle-like horn to warn other traffic of their presence on the track); "b" is a carriage wheel. Maximilian's depictions are quite satisfactory as documents, but the Prince, in selecting Bodmer as an illustrator, clearly wanted – and obtained – greater detail and aesthetic impact.

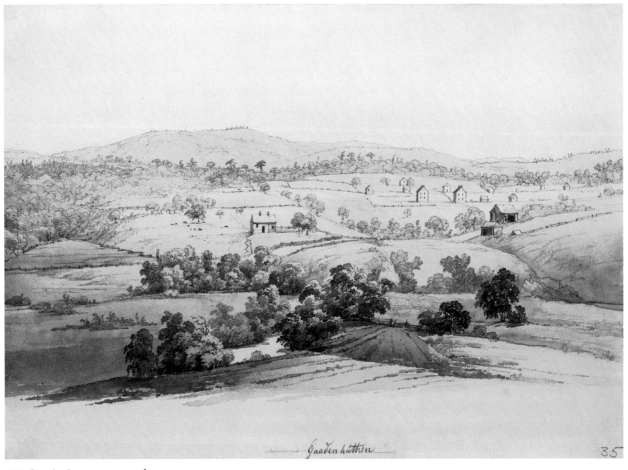

13 Gnadenhutten, watercolor on paper.

Numerous barges can be seen, along with the loading shed and the railway, in Bodmer's perspective of Mauch Chunk *[illus. 74];* in contrast to Maximilian's ebullient descriptions, Bodmer's scene is surprisingly somber, framed by dark waters, hills, and clouds, though this may simply reflect the stormy weather Maximilian reported during their visit to the area.

The missing baggage was finally delivered to Bethlehem in early September. The men excitedly began to prepare to leave, but first had to pack up the hundreds of plants and birds and dozens of reptiles they had collected, to be shipped back to Germany. This must have been principally Dreidoppel's duty, for Bodmer was free to return to sites visited previously, to finish sketches and to hunt for yet more specimens. On such a trip, using an old gun and evidently failing to load it properly, the artist was injured when the left barrel exploded. His thumb was badly hurt, his palm burned, but he was fortunate to be travelling in the company of a physician, and also, as a friend wrote to Maximilian, "lucky that it was not his right hand. . . . I hope he will recover soon, please remember me to him most kindly."[12] It was decided that Bodmer should stay in Bethlehem to recuperate for a few days; he would catch up later with Maximilian and Dreidoppel in western Pennsylvania. Maximilian paid a bill of \$91.26½ to Woehler's Inn, which included their last eighteen days of lodging, wine (for the men), 40 quarts of rum (for the specimens), assorted supplies, and doctor bills and other services, such as the tanning of a bear skin; Maximilian must have finally obtained a specimen!

In September 1832 Bodmer visited the site of an old Moravian mission, where eleven settlers had been killed in an attack by Delaware Indians in 1755. His unfinished view of the cemetery there shows his mastery in depicting natural forms, such as the tangled beauty of the red-fruited sumac. Interestingly, at about this time, in a long letter to his brother Carl, Maximilian says that Bodmer had expressed frustration with working in watercolor, believing that he could produce twice as many sketches with a less time-consuming medium.

14 *Grave of the Brethren at Gnadenhutten*, watercolor and pencil on paper.

The Prince and Dreidoppel took a stagecoach to Reading on September 17. On their westward journey they had to change coaches several times and, on at least one occasion, they were required to pay extra for their excess baggage. Sometimes they had to wait to board a subsequent coach, for many were full and could accept no more passengers. After Reading, Harrisburg was the only sizable town (population 5,000, said Maximilian) encountered before reaching Pittsburgh, but they passed through many smaller settlements, the farms and hamlets alternating with as yet untouched wilderness: "In the meadows and the fields, the stumps of trees that had been cut down were still standing, for the whole country was formerly one unbroken forest." Always observant, the Prince routinely described the landscapes he passed through, recording and identifying the native plants and animals. He usually had something to say about the settlements as well, noting occasionally what crops were being raised and which of these seemed to be successful; building types and town layouts; businesses and industries; and the ethnic origin of the inhabitants. His comments were often neutral and factual, sometimes complimentary – and

sometimes not. He was bemused by villages that adopted the names of important European cities, such as Rome or Berlin ("in the New World composed of maybe seven to ten houses"), and regretted that there was no opportunity for Bodmer to make sketches of these small pretenders to amuse his German friends and relatives.

Maximilian and Dreidoppel arrived in Pittsburgh on September 26, and Bodmer shortly joined them, clearly feeling much better; he had begun to draw again, as evidenced by a quiet view of the Susquehanna River near Harrisburg *[illus. 15]*, executed on his journey to Pittsburgh. Maximilian and party stayed in the Pittsburgh area for two weeks. The Prince seemed ambivalent about this city of 24,000 souls (including the suburbs), admiring the many stately buildings and active industries, but deploring the "dark fog of smoke" that enveloped the city and, indeed, the entire valley, due to the abundance and therefore low price of coal in the region. He was much more impressed with nearby

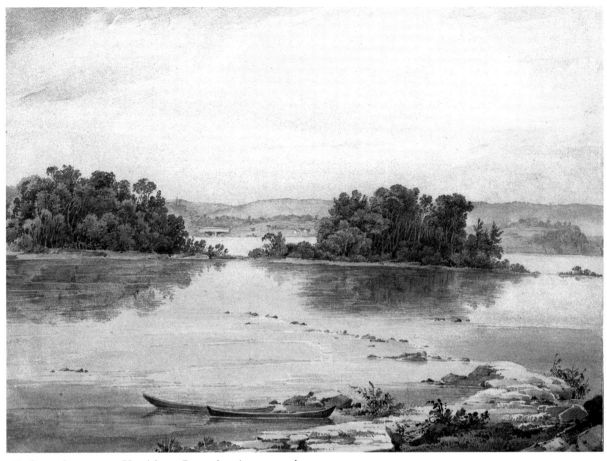

15 Susquehanna near Harrisburg, Pennsylvania, watercolor on paper.

Economy, a settlement of about 150 neatly built houses. This was the third of three utopian communities founded in the United States by the German pietist George Rapp (1757-1847) and his immigrant followers. Economy, established in 1825, was at the time of Maximilian's visit a totally self-sufficient society, with communally owned, extensive crop and animal farms; a mill; cotton, wool, and silk factories; a church; a town hall that included a small museum of natural history; and a park. All the wants of the tidily dressed inhabitants were provided for by a common fund, administered by Rapp and his family. Maximilian could find no fault with the system except that it was, perhaps, "rather too dictatorial." Bodmer's watercolor *[illus. 61],* painted on his own excursion to Economy a few days after Maximilian's, shows a compact, well-ordered town with wide parallel streets and virtually identical houses. His view of Pittsburgh *[illus. 16],* on the other hand, conveys the impression of a growing, dense, and clearly urban environment, sprawling up the hills to find room in new suburbs. The clouds that rise from behind the hills may be smoke from the nearby coal mine fires Maximilian says were burning then. Bodmer's vantage point appears to be from the banks of the Monongahela River; a covered bridge spanning the Allegheny River is seen at the midpoint of his composition. The two rivers merge at Pittsburgh and form the Ohio, which was to be the route next followed by Maximilian and crew as they continued westward.

However, the Ohio at Pittsburgh was currently too shallow for steamboat navigation, so on October 8 the travellers booked stage passage to Wheeling, West Virginia, where they hoped to embark on a suitable vessel. Among the items that

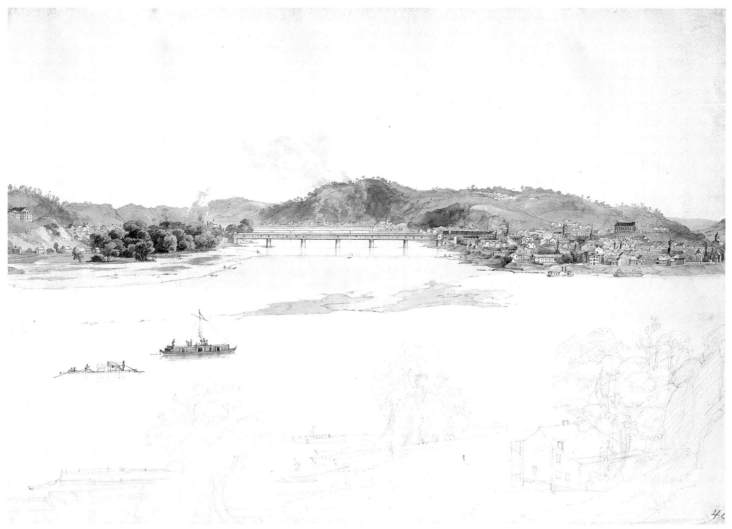

16 View of Pittsburgh, watercolor and pencil on paper.

caught Maximilian's omnivorous attention along the way were the foliage, "adorned with the most beautiful varied tints of autumn, a circumstance which distinguishes North America, at this season, from . . . other countries," and a roadside monument to Henry Clay, who is said to have lobbied for the construction of that particular throughway. At Wheeling they purchased tickets for Cincinnati, $12.00 per passenger, and they sailed on the steamer *Nile* on October 9.

Maximilian found the banks of the Ohio similar to the landscape he travelled through in Pennsylvania: forested areas alternated with farm sites and villages, albeit at greater distances. Bodmer's numerous sketches of the Ohio visually

confirm Maximilian's impressions of the verdant, unpopulated banks, the small, isolated settlements, and the volume of river traffic. The voyage was neither simple nor easy. The low level of the river occasionally grounded and delayed or damaged the steamers, and there was a constant danger of fire; on October 12, "we learned that [earlier in the day] our vessel had caught fire, but happily it was . . . extinguished." The travellers changed ships twice, once at Cincinnati, and again just below Louisville, before reaching their intended destination of Mount Vernon in Indiana. Upon arrival in Cincinnati on October 13, they were informed that cholera was raging, carrying off forty people a day, including the death

17 Rockport on the Ohio, watercolor on paper.

18 Ohio River near Rome, watercolor on paper.

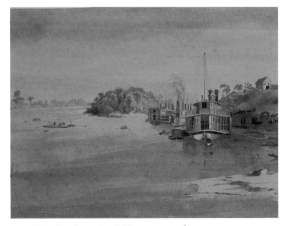

19 Portland on the Ohio, watercolor on paper.

that morning of a visiting German botanist. Maximilian resolved not to tarry, but he regretted missing the opportunity to explore "the most important and flourishing town of the West, with more than 36,000 inhabitants." One of the sights he had wanted to see was "the museum of Mr. Dorfeuille," which had many interesting natural history specimens, although, like most American museums, it also showed "absurd and trivial" objects as well, in this instance "a representation of hell."[13]

They continued their voyage on the steamer *Portsmouth,* arriving the following day in Louisville, a fast-growing town of 12,000. Maximilian sought out a German merchant to whom he had a letter of introduction. Mr. Wenzel showed him various points of interest, including a race course where races were scheduled that day; the Prince thought that horse-racing, "an institution quite new in the Western States," would be beneficial in improving the already fine breed of horses, as well as in providing the town with a source of entertainment. In his descriptions of the citizenry, he was not so kind, criticizing the over-concern for fancy clothes and the acquisition of wealth (which he felt characterized the country as a whole), and the bad manners and indolence of the young men who patronized the inns – they "thronged around the open fire, with their legs in the air [and] their hands folded on the nape of their necks." Bodmer's facile pencil sketch of *Gentlemen at Louisville [illus. 20]* seems a perfect illustration for Maximilian's diatribe; one can almost hear the idle conversation and easy laughter of these relaxed individuals.

On October 15 Maximilian, Bodmer, and Dreidoppel boarded the *Water Witch,* "a neat ship of medium size, with two decks." Engine trouble delayed their journey, but the time necessary for repair allowed the men several hours to explore the Indiana forest. There was a further and more frightening delay on the 18th, when "it was discovered that we had the cholera on board. A man from Kentucky," who had been fine the night before, "declared himself ill early in the morning, and was dead before eleven o'clock, though the Captain employed all the remedies in his power." A coffin was hastily made of planks and the man was buried ashore. The uneasy passengers were asked to leave the ship temporarily while the vessel was fumigated. Some attended the burial; others took a walk. Maximilian opted for the

20 *Gentlemen at Louisville*, pencil on paper.

former, characteristically studying the flora around the gravesite, which included a reed he believed to be used by American Indians for arrowshafts and pipestems. The voyage resumed, and the *Water Witch* steamed by Evansville and Henderson before arriving at Mount Vernon shortly before midnight. Maximilian and his companions disembarked and found lodging for the night, intending to proceed north to New Harmony in the morning. Neither Maximilian nor Dreidoppel were feeling well. Both had suffered periodically from digestive complaints, and they must have felt particular apprehension after their recent exposure to cholera. Fortunately, theirs was not so deadly a problem, but Maximilian required such a lengthy convalescence that their stay at New Harmony, "at first intended to be only for a few days, was prolonged . . . to a four months' winter residence."

New Harmony began as one of Rapp's theocratic communes. Founded in 1814, the land and buildings were sold in 1825 to Robert Owen, when Rapp and his followers moved to Economy in Pennsylvania. Owen, a British social reformer, and William Maclure, the president of Philadelphia's Academy of Natural Sciences, envisioned a different kind of utopian society, one based on science and education. To this end several learned scholars and specialists were brought to New Harmony. Though the experimental colony had not thrived, there still resided in the settlement two eminent scientists, Thomas Say and Charles-Alexandre Lesueur. Say *[illus. 69]*, principally an entomologist, had been on two American frontier expeditions with Major Long; Lesueur *[illus. 70]* was respected for his zoological studies in Australia as well as North America. An excellent natural history library had been established for the scientists' use, which Maximilian found to be, in this remote area, "a rather unusual phenomenon!" The Prince was eager to take advantage of the many learning opportunities at New Harmony.

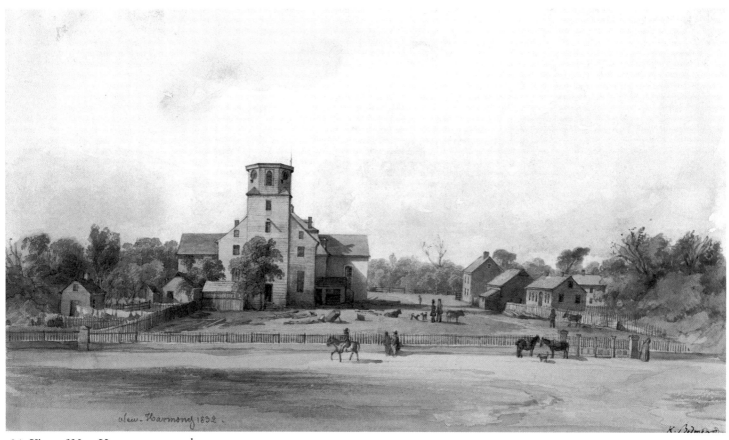

21 View of New Harmony, watercolor on paper.

Maximilian described New Harmony as a large village, with a population of about 600, brick buildings and broad, unpaved streets. The townsite on the Wabash River was pleasantly situated, surrounded by fields, orchards, and nearby woodlands. Bodmer's views of New Harmony mirror the Prince's prose. The large building at the center of *View of New Harmony [illus. 21]* (seen more distantly from another angle in *New Harmony, Indiana [illus. 22])* is one of two churches constructed by Rapp. The steeple of this one is missing, said to have been destroyed by lightning. (Maximilian's tone is disapproving when he comments that the other church had been converted by the more worldly utopians into an amateur theatre.) Lesueur's brick house is the furthest to the right of the old church.

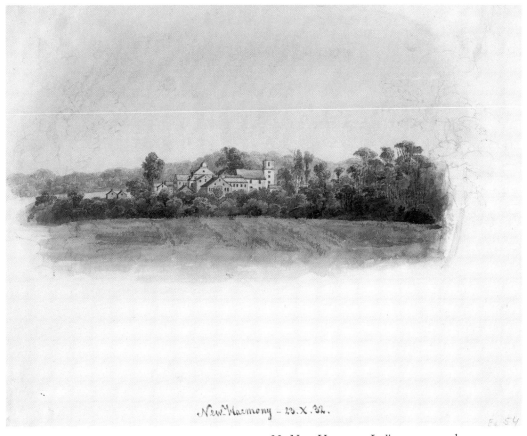

22 New Harmony, Indiana, watercolor on paper.

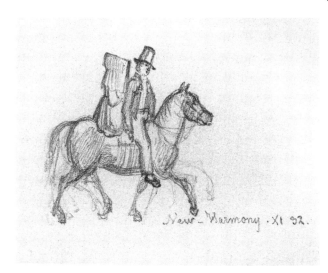

23 Backwoods Man and Woman on Horseback,
pencil on paper.

The Prince's notes contain a wealth of detail about the inhabitants of the region (lawyers, physicians, and merchants, as well as numerous settlers or "backwoodsmen, . . . a robust, rough race of men"); the crops and industries (the latter including smiths, wheelwrights, a sawmill, a brewery, and four whiskey distilleries); exports (principally pork, beef, and whiskey, shipped downriver to New Orleans); and even on the construction of what he found to be an unusual form of plough. But what interested him most was the rich diversity of plants and animals in the extensive Indiana forest. He went out every day that the weather and his health would permit him, and his diary is a Linnaean litany of the species he encountered and collected. Maximilian's sometimes dry prose becomes more emotive in his descriptions of the "romantic" riverbanks, the lush entanglements of forest growth, the "dazzling whiteness" of the sycamore bark, and the red and violet shades of the sunsets. Bodmer

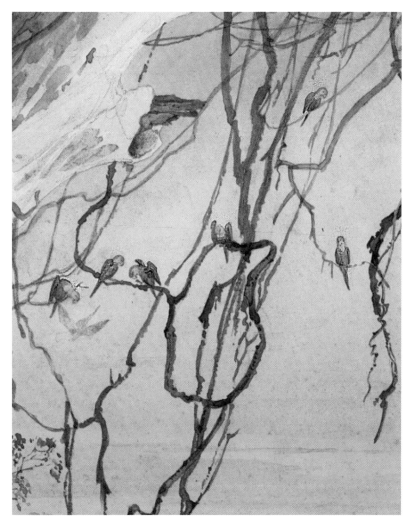

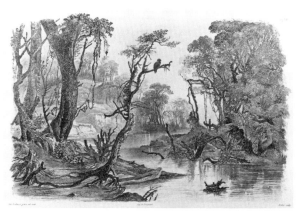

25 after Karl Bodmer, *Cutoff-River, Branch of the Wabash*, engraving with aquatint, hand-colored.

24 (detail) *Confluence of the Fox River and the Wabash,* watercolor on paper.

26 *View on the Mississippi,* watercolor on paper.

once again provides a visual translation of the Prince's observations, in two of his most impressive watercolors *[illus. 76 and 77],* where the white tracery of the branches frames our view of the quiet flow of the Fox River. And once again he provides a document, for perched in the foreground tree of *Confluence of the Fox River and the Wabash [illus. 24]* are a half-dozen Carolina parakeets. Hunted for sport and killed as agricultural pests, the species (the only parrot native to the United States) is now extinct, but the brightly feathered birds were present in large flocks in the 1833 eastern forest. Maximilian and Bodmer, who hunted the parakeets as they did all

animals, for science and for sport, also kept a wounded one as a pet.

During the months at New Harmony Bodmer appears to have divided his time equally between his art and the search for specimens. But by the end of December he may have been restless, for he volunteered to accompany a shipment of Maximilian's growing collection to the port of New Orleans, where the crates would be forwarded to Germany. The Prince agreed, probably in part because he himself was still indisposed and not inclined to such a journey; because he knew that Bodmer would be able to collect different species

in the South; and because he believed that Bodmer might encounter Native Americans there. Maximilian was deeply interested in American Indians; he read everything he could find on the subject, and interviewed the only resident who could recall the expelled original inhabitants of the New Harmony area. He castigated the citizens and government of the United States for their treatment of native peoples, and noted angrily the cruelty of "Cherokees, Choctaws and other[s]" being driven from their homes "in the course of this winter," one of many upheavals resulting from the Indian Removal Act of 1830.

On January 3, 1833, Bodmer departed from Mount Vernon on the steamboat *Homer*. Among the small settlements stopped along the Mississippi, to take on wood or conduct business, was Natchez, notorious for gamblers, but thriving on the commerce of the river. One could see Spanish moss in the trees, and the young artist reported later to Maximilian that the climatic change on the river journey had been remarkable: ". . . we came in two days from . . . total winter into the most beautiful spring!" The

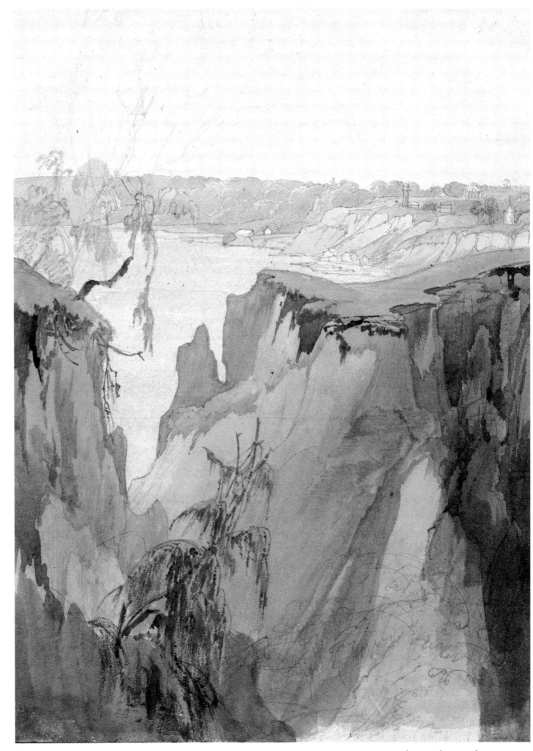

27 Lighthouse near Natchez on the Mississippi, watercolor and pencil on paper.

28 *Deck Plan of the Steamboat Homer,* watercolor and pencil on paper.

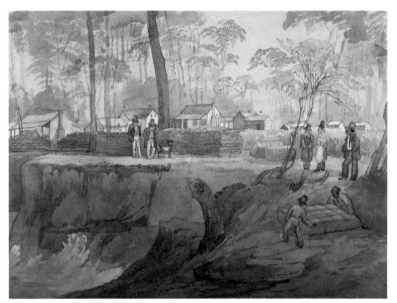

29 *New Mexico on the Mississippi,* watercolor on paper.

30 Broadside advertisement for the sale of plantation, slaves, and equipment, New Orleans, January 11, 1833.

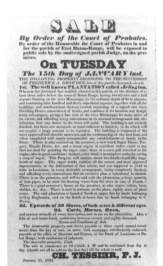

Homer landed at New Orleans on the morning of January 14. Bodmer stayed in the home of a pharmacist, Joseph Barrabino, a multi-lingual Italian who was a friend of Lesueur and a student of natural history; Barrabino was delighted by Bodmer's company and his "fine manners and character."[14] He secured for the artist the opportunity to draw several Choctaws *[illus. 32, 33, 34, and 35]*, recently deprived of their homelands and evidently unwilling to be removed with their tribe further west to new land in Indian Territory. "[O]nce mighty and illustrious," they now lived in degraded conditions, selling what they could in the local marketplaces. Sad to observe as well was the treatment of blacks: "Mr. Bodmer saw how they were sold and punished. A Negro woman was . . . [publicly] hanged, because she had struck the supervisor of the slaves." Bodmer collected a number of broadsides relating to the sale of slaves and other "property" *[illus. 30]*. One of the most affecting of these lists individually by name eighty-two "Valuable acclimated servants" to be auctioned on January 19, 1833, at the Exchange Coffee-House:

Prince, is aged about 34 years, has been upwards of 20 years in the country, is a strong, able bodied hand for a Cotton-press, or any other labouring work, is a first rate wood-cutter, is honest, sober and industrious . . .

Jim, aged 13 years.

Jolly, his brother, aged 10 years . . .

Dorcas, aged 40 years, a tolerable good cook and seamstress, and possesses a good character . . .

Maximilian, copying from a contemporary newspaper account, cited a census by state of free Negroes and slaves that tallied over two million slaves "in [this] country of exalted liberty!"

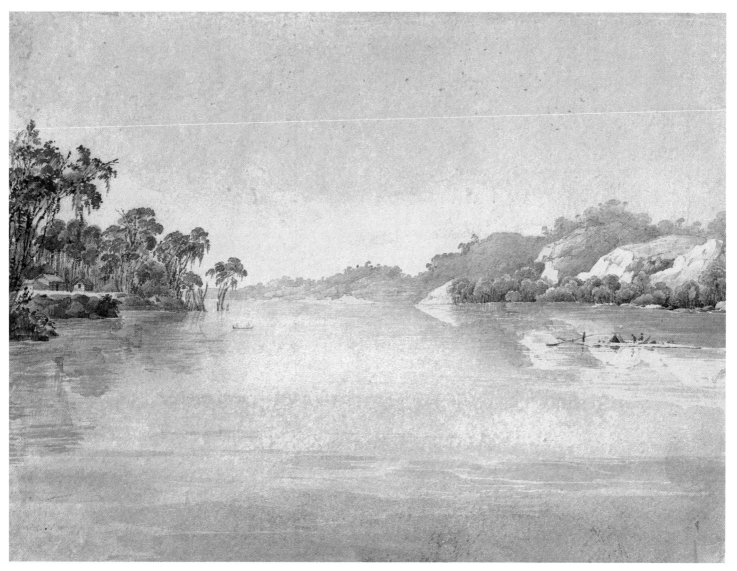

31 Fort Adams on the Mississippi, watercolor on paper.

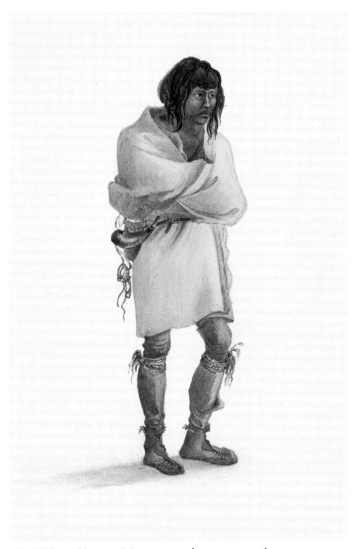

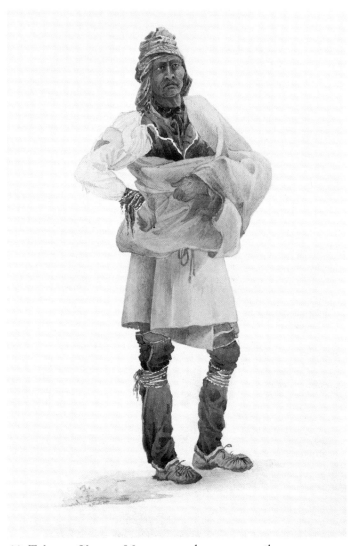

32 Billie, a Choctaw Man, watercolor over pencil on paper.

33 Tulope, a Choctaw Man, watercolor over pencil on paper.

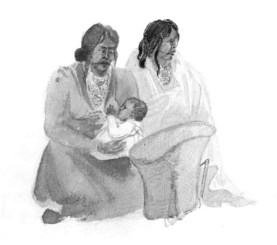

New-Orleans T. 1833.

35 *Choctaws at New Orleans,* watercolor over pencil on paper.

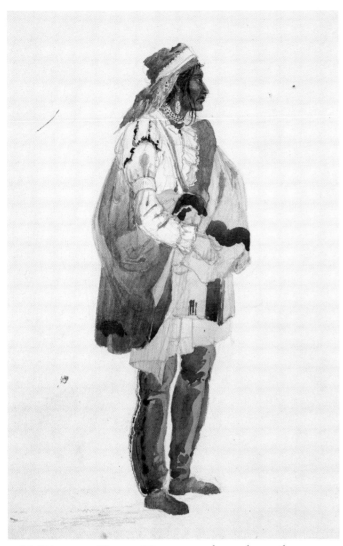

34 *Tshanny, a Choctaw Man,* watercolor and pencil on paper.

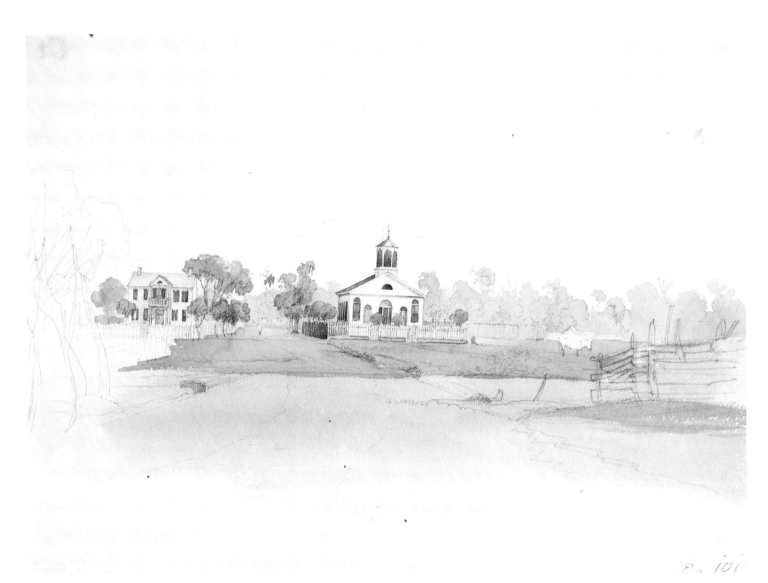

36 Church at Baton Rouge, watercolor and pencil on paper.

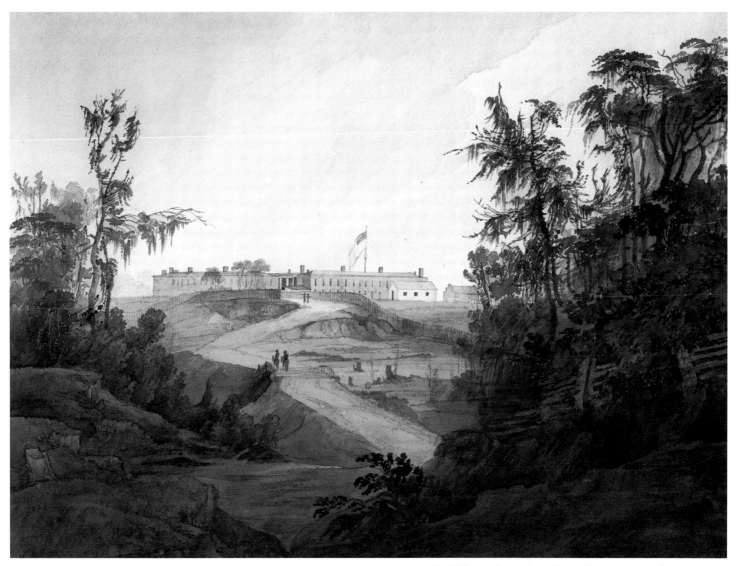

37 Military Barracks at Baton Rouge, watercolor on paper.

After seeing a few sights, assembling an assortment of zoological specimens, and concluding some banking business for Maximilian, Bodmer departed from New Orleans on January 22 on the steamer *Arkansas*. He spent three days at Baton Rouge, where he made a few sketches, including a view of the military barracks there *[illus. 37]* (which one of the resident soldiers wanted to buy from Bodmer), and the steamboats *Lioness,* loaded with cotton bales *[illus. 39],* and *Napoleon [illus. 62].* He stopped again, this time for eight days, further upriver at Natchez. While there he made an excursion to a Choctaw encampment outside the town *[illus. 40],* and took note of the bustling cotton business, which at harvest time required constant steamboat traffic between Natchez and New Orleans. The final leg of his river journey, on the *Cavalier,* was enlivened by a fight between two passengers, which threatened to escalate into a pistol duel; Bodmer must have been relieved to land at Mount Vernon the following morning, and he rode quickly to New Harmony.

38 Baton Rouge on the Mississippi, pencil on paper.

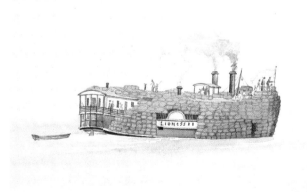

39 Cotton Boat near Baton Rouge: The Lioness, watercolor on paper.

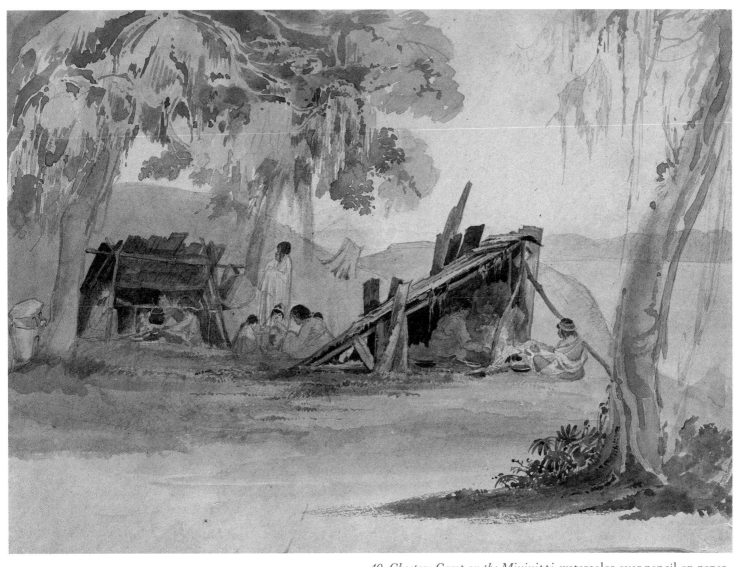

40 Choctaw Camp on the Mississippi, watercolor over pencil on paper.

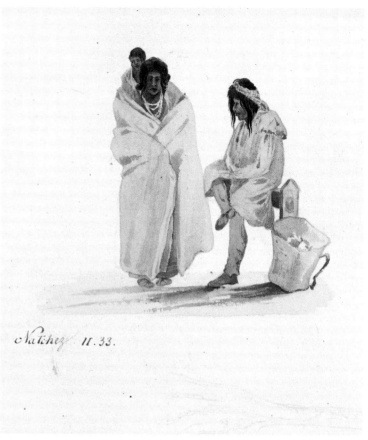

42 *Choctaws at Natchez,* watercolor and pencil on paper.

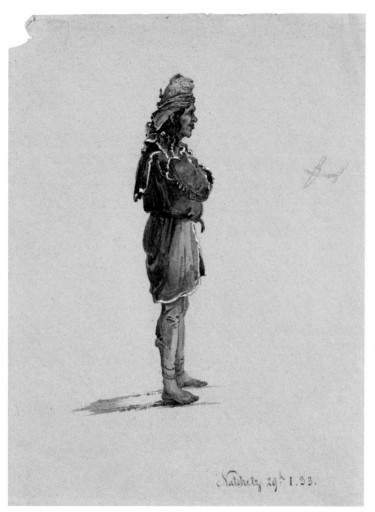

41 *Tsholocha, a Cherokee Man,* watercolor over pencil on paper.

Maximilian was pleased with the items of natural history that Bodmer sent from New Orleans, which included 13 live turtles, assorted shells, and several preserved snakes, the latter courtesy of Mr. Barrabino. The young artist shared his stories and his pictures with the New Harmony residents. He must have talked with Lesueur about the Native Americans he saw; Lesueur had earlier given Maximilian copies of three Choctaw portraits he had drawn on an 1830 trip to Mississippi [illus 43].

It was nearly spring, reports indicated that the cholera had abated most everywhere and was not in evidence at St. Louis, and the travellers were in good health and spirits. With grateful thanks they took leave of their colleagues at New Harmony and steamed from Mount Vernon on March 18. It was an uneventful passage, and Bodmer had time to record some of the scenery, both serene [illus. 45] and spectacular [illus. 46]: "The [multicolored] calcareous rocks were frequently very singularly formed, . . . [such as] the interesting Grand Tower, an isolated, cylindrical rock, from sixty to eighty feet in height, which . . . was splendidly illumined by the setting sun." On March 24, the men beheld "to our great joy," the frontier town of St. Louis.

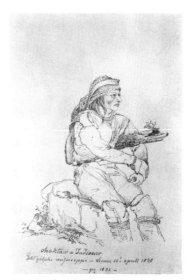

The Choctaw portraits which Lesueur gave to Maximilian were likely the first original likenesses of Native Americans obtained by the Prince. He must have been pleased by Bodmer's more lifelike renderings, harbingers of the artist's later great achievements in Native American portraiture.

43 Charles-Alexandre Lesueur, *Chaktaw Indianer*, 1830/32, pencil on paper.

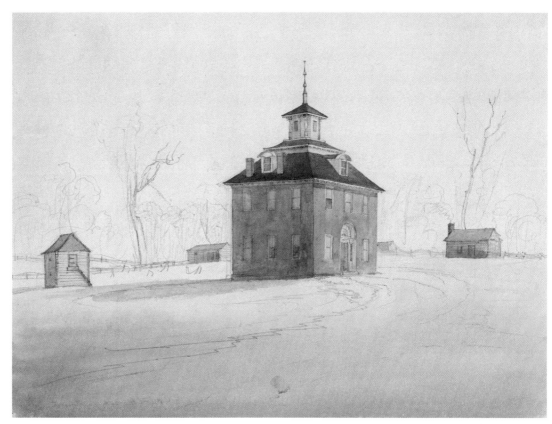

44 *Courthouse at Mount Vernon*, watercolor on paper.

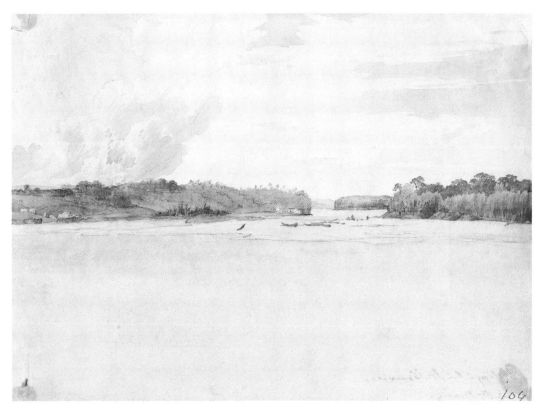

45 *The Mississippi near Ste. Geneviève*, watercolor on paper.

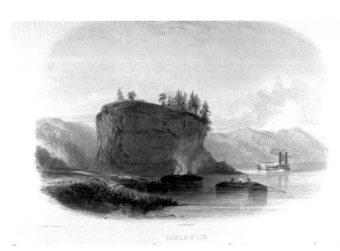

46 after Karl Bodmer, *Tower-Rock, View on the Mississippi*, engraving with aquatint, hand-colored.

Two weeks later Maximilian, Bodmer, and Dreidoppel left St. Louis and began a one-year sojourn on the Missouri River, a journey that extended nearly as far north and west as present-day Great Falls, Montana. It was an extraordinary adventure, taking them through fantastical landscapes, introducing them to Native American cultures and individuals, and subjecting them to not inconsequential dangers – in the starving cold of the 1833-34 winter, Maximilian nearly died of scurvy. They returned to St. Louis in late May, and on June 3, 1834, began to retrace portions of their earlier eastern journey.

There was a brief, happy reunion in New Harmony with Say and Lesueur. They rode north to the old French settlement of Vincennes *[illus. 52]*, and explored the countryside there for two days while they waited for a stage with sufficient room for their baggage. From Vincennes the stage took them through what is now Hoosier National Forest, which the Prince declared to be "the most splendid . . . [he] had yet seen in North America." At Louisville they boarded a steamer for Cincinnati, staying for three days to see the sights and the scientists that Maximilian had missed in 1832 because of the cholera epidemic. They then proceeded upriver to Portsmouth, where they took passage on one of the horse-drawn boats that plied the Ohio Canal. Maximilian's descriptions of the forests and the dozens of hamlets and towns they passed through, as well as of the canal boats and the locks, take the reader on a capsule tour of

47 Shot Tower near Selma, pencil on paper.

50 Trappists Hill opposite St. Louis, pencil and ink on paper.

48 Shot Tower below Herculaneum, pencil on paper.

51 Prehistoric Indian Mounds opposite St. Louis, ink over pencil on paper.

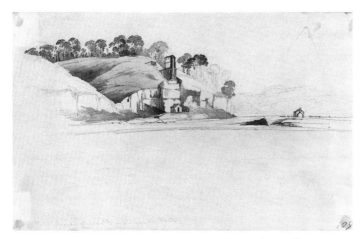

49 Shot Tower near Herculaneum, watercolor and pencil on paper.

33

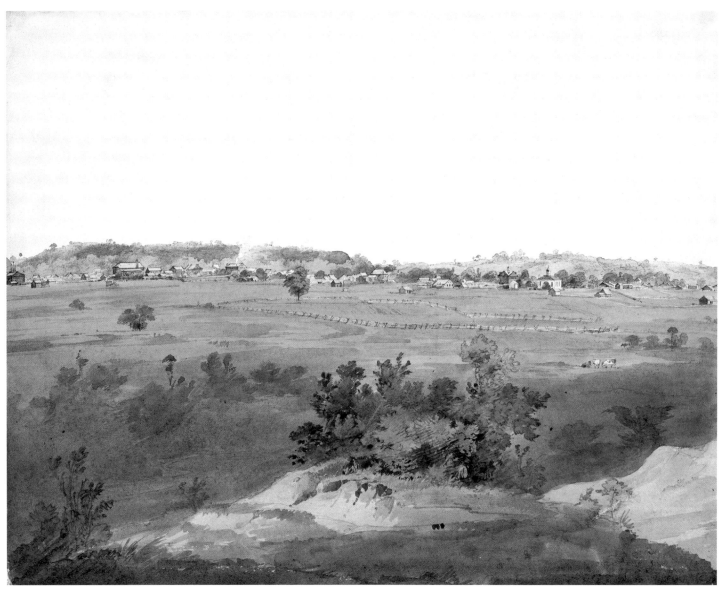

52 *Vincennes, Indiana,* watercolor on paper.

nineteenth-century Ohio. Arriving in Cleveland on June 26, the travellers were impressed by the busy city, "full of life, trade, and business," and especially by the ocean-like expanse of Lake Erie. Bodmer's depiction *[illus. 53]* of a lighthouse there certainly conveys the sense of a storm-swept sea. The men went by lake steamer to Buffalo, a town growing rapidly in size and importance, due largely to the recently constructed Erie Canal, completed in 1825. At Buffalo they took a stage to Niagara Falls, a spot

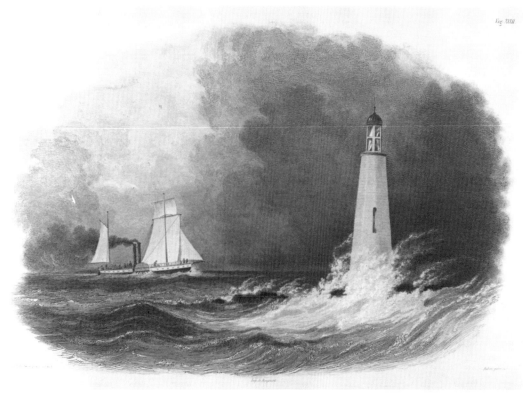

53 after Karl Bodmer, *Cleveland Lighthouse on the Lake Erie*, engraving with aquatint, hand-colored.

that had long been on Maximilian's list of key destinations. He was familiar with many published accounts, but was nonetheless unprepared for a sight so striking, so much "grander than all the descriptions I had read of it led me to conceive." Maximilian and Bodmer are among a host of authors and artists who found the Falls sublime. Bodmer's sweeping watercolor view *[illus. 54]*, later reproduced as an illustration in Maximilian's publication *[illus. 55]*, must surely be considered among the best of the myriad images of this natural wonder.

From Niagara the men travelled by stage and canal boat to Albany, and thence by steamer down the Hudson River to New York City, where they booked berths aboard the *Havre;* they sailed for Europe on July 16, 1834. In the time they spent in the eastern United States, Maximilian and Bodmer met rough frontiersmen and conversed with prominent merchants and scholars. They experienced virgin forests, raw farms and settlements, and the amenities of the country's

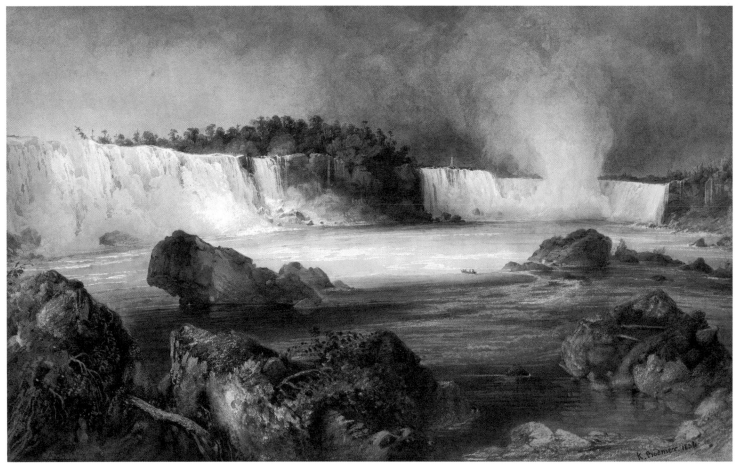

54 *View of Niagara Falls*, watercolor on paper.

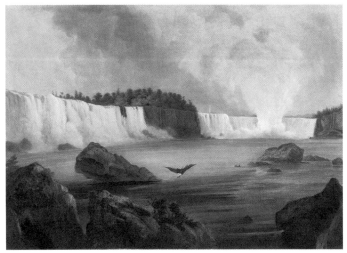

55 after Karl Bodmer, *Niagara Falls*, engraving with aquatint, hand-colored.

three largest cities. They were witnesses to the great contrasts that characterized an as yet very young America. The power of their descriptions, particularly Bodmer's minutely detailed, exquisitely rendered views, makes it possible – as the Prince promised in a letter to his family – for us to travel there, "very vividly," with them.

After returning to Europe, Maximilian prepared an account of his expedition for publication (Reise in das Innere Nord-America in den Jahren 1832 bis 1834, *J. Hoelscher, Koblenz, 1839-1841). Bodmer supervised the production of the accompanying illustrations: 33 vignettes and 48 larger tableaux; some sets were issued in black and white, others were hand-colored. Printed in limited numbers, the publication was costly to produce and to purchase; the project sustained a loss and Bodmer did not realize the financial gain he had hoped for.*

56 Loys Delteil (French, 1869-1927), *Karl Bodmer, 1809–1893*, 1894, engraving.

This portrait, printed in 1894, shows the artist as an older man. In the years following his association with Maximilian, Bodmer achieved moderate success as an illustrator, and exhibited paintings several times at the Paris Salon. The artistic recognition he sought came long after his death, and for his North American work rather than his later, largely romantic European compositions.

KARL BODMER
1809-1893

[1] Letter from Captain von Mühlbach to Maximilian, February 25, 1832. All correspondence cited is in the collection of Joslyn Art Museum.

[2] All Maximilian quotations are drawn from one or more of the following sources at Joslyn Art Museum: Maximilian, Prince of Wied, *Tagebuch*, 1832-34, a three-volume manuscript diary; English phrasing from translations on file by William J. Orr, Paul Schach, and Emery C. Szmrecsanyi. Maximilian's correspondence with members of his family during the expedition to North America; English phrasing from translation on file by Emery C. Szmrecsanyi. Maximilian, *Travels in the Interior of North America, 1832-1834*, trans. H. Evans Lloyd (London: Ackermann & Co., 1843); annotated reprint by Reuben Gold Thwaites, ed., in *Early Western Travels, 1748-1846*, vols XXII-XXIV (Cleveland: Arthur H. Clark Company, 1904-05).

[3] William J. Orr, "Karl Bodmer: The Artist's Life," in Marsha V. Gallagher, William H. Goetzmann, David C. Hunt, and William J. Orr, *Karl Bodmer's America* (Omaha: Joslyn Art Museum, and Lincoln: University of Nebraska Press, 1984), p. 351.

[4] Bodmer to von Freudenreich, who had offered to help Bodmer in his discussions with the Prince, March 2, 1832.

[5] Ernst Schwendler to Maximilian, March 9, 1832.

[6] Bodmer to Maximilian, May 3, 1832.

[7] *Albany Temperance Recorder . . . Extra*, November 6, 1832, vol. 1, no. 9, p. 1.

[8] Daniel Drake, M.D., "Cure of Cholera," broadside, Cincinnati, October 13, 1832.

[9] "R.H. Hobson, Fancy Stationer, Music & Printseller," printed advertisement, Philadelphia, n.d.

[10] "Young Ladies Seminary At Bethlehem Pennsylvania," printed advertisement, n.d.

[11] The town of Mauch Chunk, located about midway between Allentown and Wilkes-Barre, changed its name to Jim Thorpe in 1954, to honor the Native American Olympic athlete who is buried there. For a more complete discussion of the history of Mauch Chunk, see Chapter 8 in John F. Sears, *Sacred Places: American Tourist Attractions in the Nineteenth Century* (Oxford: Oxford University Press, 1989).

[12] Frederick Gebhard to Maximilian, October 5, 1832.

[13] Maximilian is referring to the Western Museum, established in 1820. When it failed three years later, the curator, Joseph Dorfeuille, took it over and tried to make it work as a commercial enterprise. The sculptor Hiram Powers (1805-1873) assisted him in creating ingenious attractions, such as an apparently very popular series of tableaux of Dante's *Inferno*. Maximilian saw this on his return trip through Cincinnati in 1834, but was unimpressed with either the "hideous scenes" of the devil, or the "vulgar multitude" who had paid to see them.

[14] Joseph Barrabino to Maximilian, April 28, 1834.

Marsha V. Gallagher is Chief Curator at the Joslyn Art Museum in Omaha, Nebraska, and was formerly the Head of the Anthropology Department at the Museum of Northern Arizona in Flagstaff. She has organized several exhibitions for both institutions, including the current Karl Bodmer's Eastern Views. *Her publications include a number of works related to Maximilian and Bodmer, most notably* Karl Bodmer's America *(with William H. Goetzmann, David C. Hunt, and William J. Orr; Joslyn Art Museum and University of Nebraska Press, 1984).*

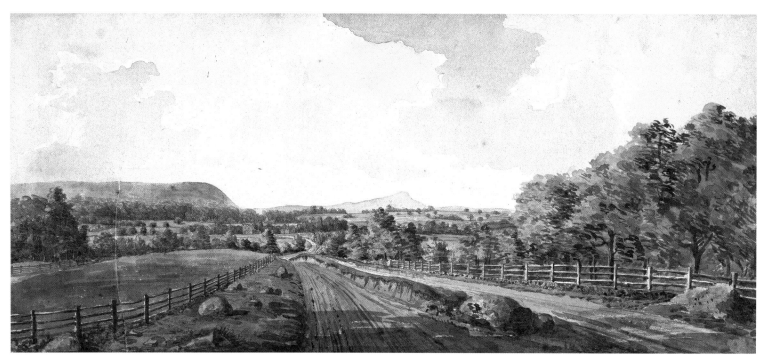

57 Benjamin Henry LaTrobe (American, 1764-1820), *Road From Newark to Patterson, N.J.*, 1880, watercolor on paper, Maryland Historical Society, Baltimore, Maryland.

KARL BODMER'S EASTERN VIEWS

by John F. Sears

Karl Bodmer is best known for his paintings of Native Americans; paintings that exhibit a realism, a respect for their subject, and attention to the details of Native American physiognomy, clothing, weapons, and decoration unmatched by any other Western artist of the nineteenth century. Without romanticizing his subjects, Bodmer presents them as strong, dignified people richly adorned with the beautifully wrought products of their cultures. The quality of his paintings is all the more extraordinary because Bodmer's earlier and later work as a painter is undistinguished. Although his work received recognition only after the original watercolors were brought to light at the end of World War II – and he himself apparently failed to recognize what he had achieved – the circumstances in which he worked for two years with Prince Maximilian among the native peoples of the upper Missouri enabled him to produce a brilliant and original body of work.

Bodmer's reputation rests primarily on his images of the landscapes and native peoples of the upper Missouri River, but his eastern paintings are also unique. A few of the sites he painted were beautifully depicted by others, but nothing compares in quality or scope to the pictorial record of his journey through the east. Bodmer created a visual journal of American culture at a moment when – fueled by the industrial revolution – the pace of settlement was quickening. His eastern paintings portray the European civilization, still unfinished and in many instances juxtaposed to wild nature, that would soon engulf the primeval landscape and indigenous peoples he would encounter on the upper Missouri.

Bodmer's work is contemporary with that of Thomas Cole and James Fenimore Cooper, which glorified the American landscape, transforming it into "scenery" and a national iconography through painting and description. But unlike them, Bodmer brought no nationalistic motives to his work. His purpose was not to produce an American art, or to sell his work to Americans eager to take pride in their new country, but rather to serve the scientific goals of his employer, Prince Maximilian zu Wied-Neuwied, a German naturalist on an expedition to study the flora, fauna, and native peoples of the American West. Bodmer's images have more in common with the visual journal of the eastern United States kept by the architect Benjamin LaTrobe *[illus. 57]*, which mixed picturesque views with topographical and scientific illustration,[1] than with Cole's panoramic landscapes. But Bodmer's work is far superior to LaTrobe's, more finished and vivid.

Bodmer arrived in America in July 1832 with Prince Maximilian and David Dreidoppel, who had long served the Wied family as expert hunter and taxidermist. The three men spent eight months in the eastern and central United States before heading north from St. Louis to the upper Missouri. This was an important period of preparation for their work in Indian territory. Bodmer immersed himself in his role as illustrator for Maximilian, eagerly sought out and painted the landscapes along their route, joined in the scientific work of the expedition, and participated in the cultural and intellectual world in which Maximilian moved when he was in the United States. Maximilian kept a diary of the journey that recorded the geography through which they passed, details about the communities and frontier settlements they visited, and descriptions of the flora and fauna they observed and collected. This diary served as the basis for his published *Travels in the Interior of North America in the Years 1832 to 1834 (Reise in das Innere Nord-America in den Jahren 1832 bis 1834)* (1839-43), which was accompanied by an atlas

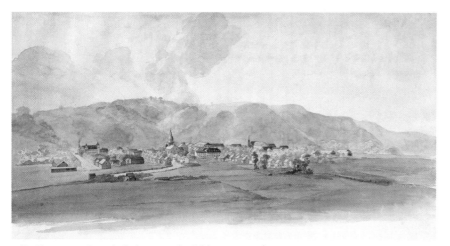

58 *Economy, Rapp's Colony on the Ohio,* watercolor on paper.

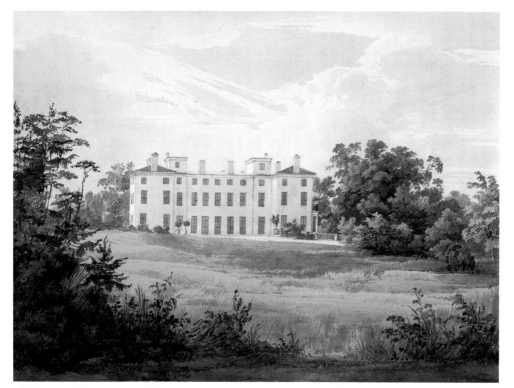

59 *Manor House of Joseph Bonaparte near Bordentown,* watercolor on paper.

containing engravings of eighty-one of Bodmer's drawings and watercolors.

Maximilian's itinerary and Bodmer's subject matter and manner of depicting the landscape of the eastern United States were primarily determined by three factors: Maximilian's interest in and ties to the German settlements in America; tourism and the picturesque tradition of landscape painting; and the scientific purposes of the expedition.

Maximilian's visits to Bethlehem, Pennsylvania, a predominantly German village founded by the Moravians, to other Moravian settlements in the area, and to Economy, Pennsylvania, a utopian community founded by the German religious leader George Rapp, were motivated by his interest in the fate of the German immigrants who had fled from persecution in their native land. Maximilian's grandfather had made the city of Neuwied a haven for European political and religious refugees, including Mennonites and the Moravian Brethren.[2] It is likely that the respect for Native American cultures and detestation for American slavery that Maximilian expresses in his diary and *Travels* derived in part from having grown up among people from diverse religious and cultural backgrounds. Bodmer's paintings of the German settlements pay tribute to the peacefulness and prosperity the immigrants had achieved and, in the case of his painting of Gnadenhutten, the hardships of their early years.

These settlements were also part of the emerging tourist landscape of the period, however, and Bodmer's depiction of them reflects his previous work as an illustrator of a book of tourist views of the Moselle River. Maximilian probably chose Bodmer as the expedition's artist partly for his ability to produce just such attractive views for the publication he was planning. Bodmer's experience in viewing landscapes with a tourist audience in mind was reinforced by his arrival in the United States just as tourist routes and destinations were being established. During his passage through the east, Maximilian was an avid buyer and reader of the guidebooks that had just begun to appear in the United States in the mid-1820s, and these no doubt helped to determine his itinerary, stopping places, and sense of what was important to record. A number of the sites that Bodmer painted, such as Mauch Chunk, the Delaware Water Gap, and Niagara Falls, were already established as tourist sites and, because of the status they had achieved in the American cultural landscape, were appropriate illustrations for Maximilian's projected book. The country estates of prominent people also attracted attention in the guidebooks, particularly if, like Joseph Bonaparte's (Napoleon's older brother) Point Breeze [illus. 59], they possessed significant historical associations. Other subjects depicted by Bodmer, such as the Pittsburgh prison and Economy, were on tourist itineraries as part of the American landscape of reform. Created in a period of optimism about human nature, the innovative institutions Americans were constructing to care for the deaf, dumb, and blind and for the criminal and insane were considered the most advanced in the world. They attracted foreign visitors such as Alexis de Tocqueville, Harriet Martineau, and Charles Dickens, as well as domestic tourists. The technological innovations recorded by Bodmer, such as canals and steamboats, which were making increased travel possible [illus. 63], were also part of the tourist landscape. So were places such as Mauch Chunk [illus. 74], where tourists viewed the large, open-pit anthracite mine at Summit Hill and rode on the novel gravity railroad that carried coal from the mine to the Lehigh River, where it was loaded onto canal boats.

As part of his training and experience in producing scenic views, Bodmer brought with him a sense of the "picturesque." The picturesque denoted a style of landscape that

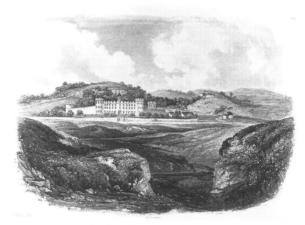

60 after Karl Bodmer, *Penitentiary near Pittsburgh*, engraving with aquatint, hand-colored.

61 The Prison in Pittsburgh, watercolor and pencil on paper.

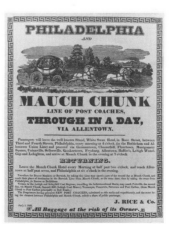

62 Broadside advertisement for the *Philadelphia and Mauch Chunk Line of Post Coaches*, 1832.

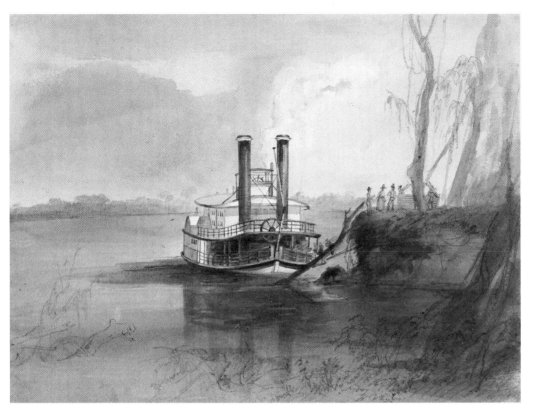

63 *The Steamboat Napoleon,* watercolor and pencil on paper.

64 after Karl Bodmer, *Cave-in-Rock, View on the Ohio,* engraving with aquatint, hand-colored.

combined the wild and the cultivated, the rough and smooth, nature and human associations. The term also referred to the popular mode of looking at landscapes as if they were paintings. Before the advent of the camera, tourists often carried sketchbooks with them and recorded their impressions of the scenery around them. They were encouraged by William Gilpin's "Essay on the Art of Sketching Landscape" (1794) and other guides to picturesque travel and illustration to locate the proper vantage point from which to most effectively compose the landscape before them into a picture. Bodmer follows the conventions of this touristic mode of painting in many of his watercolors of the eastern United States. In his two views of Bordentown, for example *[illus. 65 and 66],* he alters the hill on the left in the second version of the painting to create the balanced, framed view he seeks.

Tourism and Maximilian's interest in the German settlements, however, were not the most significant influences on the content and aesthetics of Bodmer's paintings. His vision was clearly molded by Maximilian's scientific motives. Maximilian's main object was the scientific observation and description of America's fauna, flora, and native peoples, and Bodmer was employed by Maximilian to produce the visual documentation for this work. Maximilian's scientific purpose and Enlightenment view of mankind, including his respect for non-European peoples and their cultures, not only determined Bodmer's choice of subjects but also the realism with which he recorded them. Although this realism is most remarkable in

65 View on the Delaware near Bordentown, watercolor on paper.

66 View on the Delaware: Joseph Bonaparte's Garden, watercolor on paper.

Bodmer's depictions of the native peoples of the West, it is already evident in his earlier eastern images. Moreover, the subjects of the eastern paintings reflect Maximilian's ties to the European-American scientific community centered in Philadelphia.

Maximilian's view of the world was shaped by the liberal milieu in which he spent his youth and by his education at the University of Göttingen, a famous center of the Enlightenment in Germany. Maximilian admired Alexander von Humboldt, the great German geographer and naturalist, whom he met in 1804 and who strongly influenced the Prince's career. Humboldt's work *Cosmos* (1845-58),[3] in which he assigned landscape painters a vital role in the study of nature, would later become influential in the United States, inspiring Frederic Church to visit South America and paint its volcanoes and jungle landscapes. Like Humboldt, Maximilian attended the University of Göttingen. There he studied with Johann Friedrich Blumenbach, one of the founders of anthropology. Blumenbach's specialty was the study of the natural varieties of the human race, and he inspired his students to consider human beings, as well as plants and animals, a subject of natural history. Maximilian's time at Göttingen not only had an important impact on the enlightened way he viewed the peoples of North America and their displacement by European settlement, but possibly influenced the logistics of his journey as well. Among the many Americans studying at Göttingen while Maximilian was there was William Backhouse Astor, a son of John Jacob Astor, the man who controlled the fur trade on the upper Missouri. It is likely that the Astors assisted Maximilian in planning and undertaking his 1832-34 expedition, which included passage up the Missouri River on the *Yellow Stone*, a steamboat owned by Astor's American Fur Company.

Inspired by Humboldt's five-year expedition to Latin America, Maximilian spent two years in Brazil, from 1815-17, studying the flora and fauna and collecting specimens. His special interest was in zoology but, prepared by his study with Blumenbach, he was also eager to learn about the native peoples.[4] This earlier field experience fueled Maximilian's desire to study the natural history of North America and particularly its native peoples before their cultures were destroyed by European settlement.

The main focus of Maximilian's work in the east, as his diary makes clear, was on the study of the country's flora and fauna, and the character of this scientific enterprise shaped Bodmer's role as the expedition's artist. Maximilian and Bodmer came to America during an exciting period in natural history. The heart and soul of natural science at the time – particularly in North and South America where thousands of plants and animals had yet to be named by Europeans – was accurate observation and classification rather than theory. Scientists competed, sometimes hotly, to become the first to identify and name a new species. Although caricatured in James Fenimore Cooper's *The Prairie* (1827) as Obed Battius, a bumbling figure weighted down with fussy, impractical knowledge and Latin terminology, the naturalist of the time had to be a rugged and intrepid individual capable of journeying into uncharted territory to collect and preserve specimens under difficult conditions.

A major impetus to the work of natural scientists throughout the nineteenth century were the expeditions organized by the United States government, beginning with those led by Meriwether Lewis and William Clark in 1804-06, Zebulon Pike in 1805-07, and Major Stephen H. Long of the U.S. Topographical Engineers in 1819-20 and 1823. Maximilian made himself thoroughly familiar with the results of these expeditions, and his own journey, including the role of Bodmer in it, followed a pattern similar to the earlier explorations. Although the government-sponsored expeditions had important military, economic, and political purposes that Maximilian's enterprise did not share, they too involved the collection of botanical and zoological specimens, the acquisition of Indian artifacts, and the keeping of journals. In addition, the Long expedition included a landscape painter, a tradition that would continue down through the time of Thomas Moran, who accompanied Ferdinand V. Hayden on his 1871 expedition to the Yellowstone. In fact, the Long expedition included two artists: Titian Ramsay Peale, who was both a naturalist and an illustrator, and Samuel Seymour, a landscape painter whose paintings of

the Rocky Mountains were the first views of those mountains to be published. Edwin James' report on the Long expedition, *Account of an Expedition from Pittsburgh to the Rocky Mountains, Performed in the Years 1819, 1820* (1822-23), which served as a resource for Maximilian and Bodmer in their own travels, is more scientifically and topographically detailed than Maximilian's, but covers many of the same topics: plants and wildlife, hunting, and frontier life. Maximilian's more anecdotal account is oriented to the general reader, and Bodmer's illustrations fit this style.

The skills needed at this time for successful field work in natural history were marksmanship, taxidermy, and drawing. Titian Peale was good at all three and spent his time on the Long expedition shooting, preserving, and sketching specimens. Maximilian's diaries indicate that gathering the rich flora and fauna he and his companions encountered was central to his enterprise as well. Much of Maximilian's and Dreidoppel's time during their travels in North America was spent shooting and collecting specimens, identifying them, preparing them, packing them in cases, and shipping them back to Europe. When not painting, Bodmer was often engaged in this work as well.

In the early nineteenth century, colleges and universities did not yet play an important role in scientific investigation. Instead, naturalists affiliated themselves with learned societies, reported their findings at the societies' meetings and in their journals, and contributed specimens to the societies' collections. They also participated in an international network of scientists who corresponded, exchanged specimens with each other, and provided collections for the museums or "cabinets of curiosities" that functioned both as public exhibitions and resources for natural scientists.

Through the web of international scientific correspondence, journals, and exchanges of specimens that connected European and American scientists, Maximilian knew something of the work being carried on in America in the area of natural science. He particularly wished to visit Philadelphia before heading west, because it was the center of scientific thought and activity in the United

States at the time, and the museum established there by Charles Willson Peale contained the most comprehensive natural history collection in the United States. Philadelphia was also the home of two of America's most distinguished learned societies: the American Philosophical Society, founded in 1743, and the Academy of Natural Science, founded in 1812. The Academy of Natural Science itself had extensive foreign and domestic natural history collections supplied by members both in the United States and abroad. Maximilian would be elected an honorary member in 1834.

Philadelphia's reputation as a center of natural history had been established by John Bartram (1699-1777) and his son William Bartram (1739-1823), who were known internationally and whose collections, gardens, and travels did much to promote the study of natural history in the United States. The city's influence had been enhanced by Alexander Wilson who, as a member of the Lewis and Clark expedition, was the first naturalist to join a government expedition and whose *American Ornithology* (1808-13) was the first significant book of American natural history written, illustrated, engraved, and printed in the United States. Wilson's work set the standard that American naturalists tried to meet in their publications over the next twenty-five years. Among the naturalists who were part of the community of scientists in Philadelphia were Thomas Say, Titian Ramsay Peale, Charles-Alexandre Lesueur, Charles Lucien Bonaparte (a nephew of Napoleon), and William Maclure. Lesueur, Bonaparte, and Maclure were foreign-born, as were several of the other men in the group, and brought with them connections to scientists in Europe. Among these men the most important for Maximilian would be Say and Lesueur, who had moved to New Harmony, Indiana, in 1826 and would become his closest scientific associates during his sojourn in America. Say had deep roots in the Philadelphia community, being not only one of the founders of the Academy of Natural Science and the leader in the establishment of the Academy's *Journal* in 1817, but a great-grandson of John Bartram and a grand-nephew of William Bartram.

Although an outbreak of cholera drove Maximilian out of Philadelphia, and he did not have much direct contact with the other members of the scientific community, he did visit Peale's museum, where Titian Peale was then in charge. He examined the Indian artifacts and natural history specimens brought back by the Lewis and Clark, Pike, and Long expeditions,[5] as well as paintings made by Samuel Seymour on the Long expedition, and probably some of the Indian portraits being collected by Thomas L. McKenney for his *Indian Tribes of North America* (1836-44). In addition, it is possible that Maximilian's itinerary in eastern Pennsylvania was guided in part by his contact with Philadelphia scientists. For example, Point Breeze, the estate that Maximilian and Bodmer visited near Bordentown, New Jersey, was owned by Joseph Bonaparte, Charles Lucien Bonaparte's uncle and father-in-law.[6] Point Breeze was well known in Philadelphia for having the best collection of European paintings in the United States, an excellent library, and ornamental gardens frequently visited by such Philadelphia naturalists as Thomas Say. Maximilian and Bodmer also traveled to the Mauch Chunk area, where a number of years before, Say, Lesueur, and Maclure examined the mining operations and collected minerals, insects, and bird specimens. It is probably not a coincidence that Maximilian and Bodmer were covering ground that had already been the object of study by the Philadelphia naturalists.

That Maximilian's investigations of the natural history of the United States were being guided by the pioneering work of the Philadelphians is confirmed by his decision to visit Thomas Say and Charles-Alexandre Lesueur in New Harmony, Indiana. New Harmony was a frontier outpost of the international scientific community and of Enlightenment, reformist thought. Originally founded in 1815 by George Rapp, leader of a German religious community, it was bought by the British utopian Robert Owen in 1825, when Rapp and his followers moved to Economy, Pennsylvania. Owen, whose aim was to make industrial society less harsh, hoped to create a cooperative manufacturing and agriculture community at New Harmony. In 1825 William Maclure, who was interested in Owen's ideas, persuaded a group of educators and naturalists, including Say and Lesueur, to join him and Owen on a trip to New Harmony from Philadelphia. Maclure, a wealthy Scotsman who had made a fortune in textile manufacturing, decided to remain in New Harmony, eventually buying Owen out and establishing a school to meet what he saw as the needs of the new industrial age. Maclure, himself a central figure in the Philadelphia milieu, was the chief patron of the Academy of Natural Science and its president from 1817 to 1840, encouraging its growth by providing books and printing equipment. His school at New Harmony would emphasize natural history, mathematics, and the arts, with the aim of making useful citizens; he hoped to combine a system of education for the common man with an active community of scientists. By the time of Maximilian and Bodmer's visit, Maclure had moved on to Mexico, leaving Say in charge of the School of Education. In his paintings of New Harmony and its surroundings, Bodmer provides a portrait of this unusual outpost of European civilization.

New Harmony was an ideal stopping place for someone wishing to launch an expedition to study the natural history and the native peoples of the wild interior of North America. Thanks to William Maclure, New Harmony had an extensive library of natural history and travel books, and Say and Lesueur possessed large collections of insects, shells, fish, and other specimens for Maximilian to examine and discuss. Maximilian and Bodmer also examined Lesueur's drawings and watercolors while in New Harmony. Since Say had been a member of both the first and second Long expeditions, he was in a position not only to inform Maximilian of the natural history of the area they were about to explore, but also to furnish information about the Indian tribes he himself had studied. Of special importance to Maximilian and Bodmer were the contributions Say had made to the study of Indian ethnology as a member of the two Long expeditions, recording Indian vocabularies, myths, dances, and rituals and other detailed information on what he observed. Say held long discussions with Maximilian during the winter of 1832-33 about the tribes along the Missouri, and was probably Maximilian's most important informant on Native American life before he set off for the upper Missouri. Although Say thought the Indians superstitious, he regarded

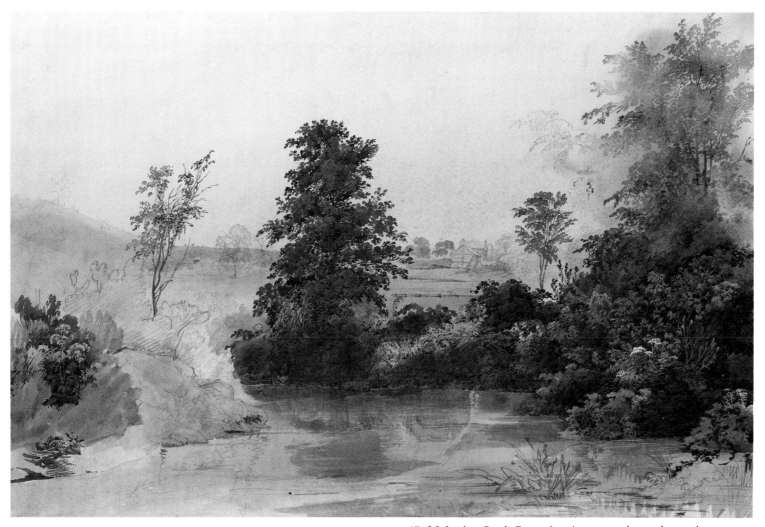

67 Mahoning Creek, Pennsylvania, watercolor and pencil on paper.

68 after Karl Bodmer, *New Harmony on the Wabash*, engraving with aquatint, hand-colored.

their religious beliefs and myths as no more foolish than those of Europeans: "Many equally absurd doctrines are believed in Christendom," he remarked to Maximilian.[7] He shared Maximilian's objections to slavery as well as to America's treatment of its native peoples.

But of more immediate importance to Maximilian and Bodmer were the guidance and companionship Say provided during numerous collecting expeditions along the Fox and Wabash rivers. Say had an international reputation as an entomologist, and Maximilian may have already known about him from the German naturalists with whom Say corresponded and exchanged specimens. Maximilian no doubt heard more about Say from Titian Peale, Say's boyhood friend, frequent companion on collecting expeditions, and fellow member of the Long expedition. Say's *American Entomology* (1817, 1824-28) was the first book to describe a large number of native insects (during his lifetime Say named 1,500 new species of insects), and his *American Conchology* (1830-34, 1836) was the first on mollusks. Although his residence on the frontier increasingly isolated him from the scientific community in Philadelphia, Say set a standard for American science with his devotion to collecting in the field, careful scientific descriptions, and pioneering work as a taxonomist.[8]

Say excelled at accurate field observation and, for Bodmer, he must have reinforced the high value Maximilian placed on the realistic recording of natural

facts. In his diary, Maximilian admires Say for his care and attention to detail: "Mr. Say is a very thorough, conscientious observer, and his descriptions and identifications are certainly very correct." Maximilian admires the same qualities in Bodmer's work, praising Bodmer's "exact drawings of toads" and the "very precise" execution of his sketches of the Salomon Creek, Mauch Chunk, and the Mahoning Valley. Maximilian also delights in the realism and clarity of Bodmer's depictions of the American landscape: Bodmer's "general view of Bethlehem with a cross-section of the Lehigh valley and the canal," he writes, is "a beautiful overview in which our living quarters" can be clearly discerned. The fact that his employer and his scientific associates valued precision so highly no doubt encouraged Bodmer to strive for realism in his work.

69 Henry Hoppner Meyer, *Portrait of Thomas Say, 1787-1834,* 1839, steel engraving.

It was because of the premium placed on accurate description and the desire to record new species that the artist was such an important ally of the naturalist in recording what he observed. In fact, naturalists at the time were remarkably often artists, and many artists were also naturalists. William Bartram produced detailed drawings of plants and animals, and Charles Willson Peale, Titian's father, was an accomplished portrait painter before turning his attention to natural history and displaying specimens in his museum against painted scenic backdrops. Alexander Wilson and, of course, John James Audubon were both painters and naturalists; Titian Peale produced most of the illustrations for Say's *American Entomology;* and Charles-Alexandre Lesueur, whose specialty as a naturalist was fish, was an accomplished illustrator who taught drawing in New Harmony and painted scenery for New Harmony theatrical productions.

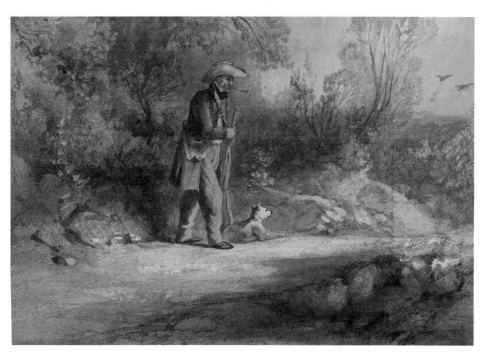

70 *Lesueur, the Naturalist at New Harmony,* watercolor on paper.

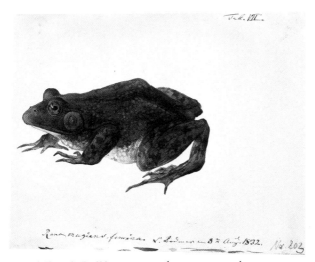

71 *A Female Bullfrog,* watercolor over pencil on paper.

72 *Salamander,* watercolor on paper.

73 *A Turtle,* watercolor on paper.

Like these other artist-naturalists, Bodmer recorded American flora and fauna, and there are some beautiful renderings of bullfrogs and toads, a white-tailed deer, a lynx, and other animals among his eastern paintings. But aiding in the process of natural history documentation clearly was not Bodmer's primary role, since the great majority of his eastern work depicts landscapes, not specimens. Specimens, of course, could be preserved and shipped back to Germany; the appearance of the landscape in which they were found could not. Thus, one of the primary purposes of Bodmer's paintings was to record the environments in which the members of the expedition collected specimens.

The goal of finding as many native species as possible, and therefore seeking out areas where plant and animal life was least disturbed by the encroachment of settlers, helped determine the sites Maximilian and Bodmer explored. Both men took delight in what Maximilian called the "sublime primeval forest," Maximilian for the rich trove of flora and fauna it yielded; Bodmer for the opportunity to paint landscapes unlike any he had ever seen. Maximilian reports in his *Travels* that Bodmer expected to find a distinctly un-European landscape when he arrived in America, but instead found a highly Europeanized one: "Mr. Bodmer . . . was not satisfied with all these landscapes: he had expected to find, at once, in America, forms differing from those of Europe; but these must be looked for under another zone; for, in North America, the general character of the vegetation resembles that of Europe."

Bodmer began to find what he was looking for west of Bethlehem in eastern Pennsylvania, where he and Maximilian were "charmed by this North American wilderness." In Bodmer's painting of Mauch Chunk, Pennsylvania, he captures the wildness of the landscape surrounding the dark terminus of the gravity railroad, where the coal from the mine at Summit Hill was loaded into canal boats. As a popular tourist attraction, Mauch Chunk was frequently portrayed, but no other nineteenth-century artist depicted the town as the raw outpost of industrialization in the midst of the American wilderness that it was in its early years.

Still further west, in Edensburg, Pennsylvania, Maximilian delighted in a "dark wilderness," which he entered to shoot specimen animals and birds. It "is so full of piles of fallen, rotting primeval tree-trunks," he wrote, "that one must often make wide detours and great leaps everywhere, in order to make progress." Such landscapes were seldom described by travelers in America in the nineteenth century and seldom painted either, since they did not fit the current conception of the scenic. One remarkable exception is Alexis de Tocqueville's description, on a trip to Lake Oneida in 1831, of a primeval forest as a "sort of chaos": "Trees of all ages, foliage of all colours, plants, fruits and flowers of a thousand species, entangled and intertwined." He is off the tourist route, in a landscape where no markers of European culture exist: "No road passes by this place; in these parts one sees no great industrial establishments, and no places celebrated for their picturesque beauty." In France, "there is no district so thinly populated and no forest so completely left to itself, that the trees, when they have quietly come to an end of their days, fall at last from decay."[9]

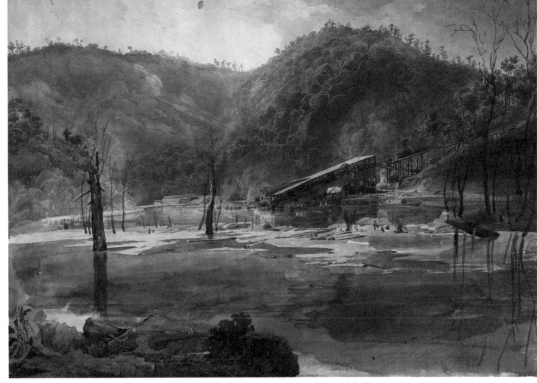

74 *View of Mauch Chunk, Pennsylvania, with Railroad,* watercolor on paper.

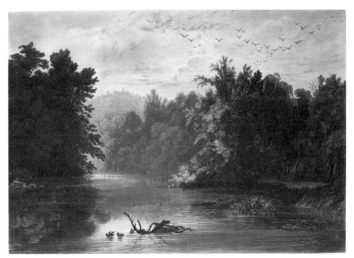

75 after Karl Bodmer, *Forest Scene on the Lehigh (Pennsylvania),* engraving with aquatint, hand-colored.

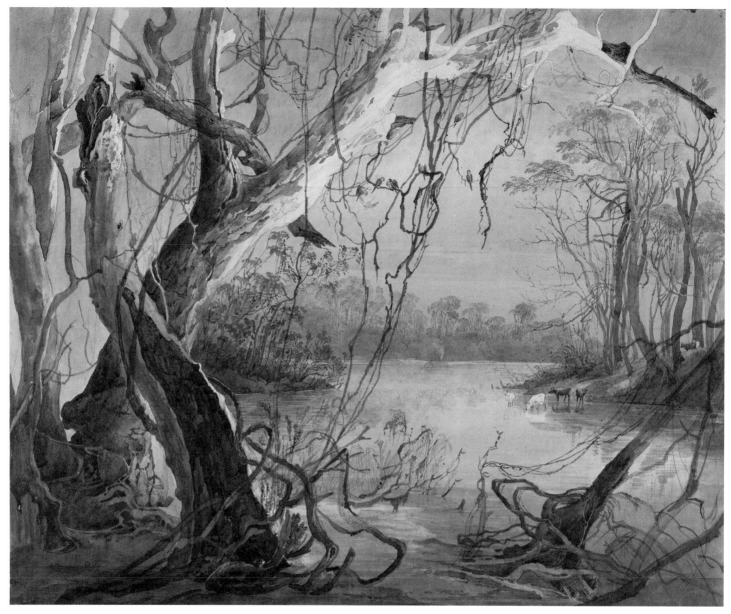

76 *Confluence of the Fox River and the Wabash,* watercolor on paper.

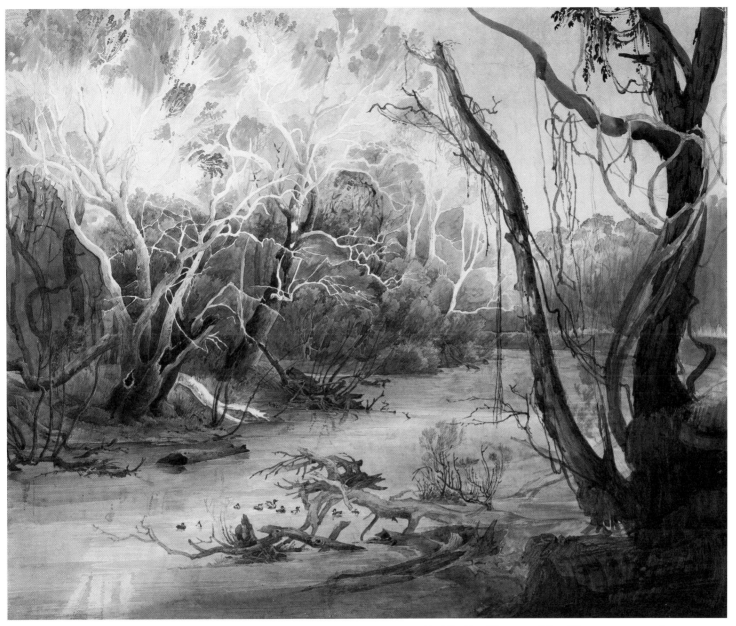

77 *The Fox River near New Harmony,* watercolor on paper.

The wildest forest landscapes that Maximilian and Bodmer encountered during their travels are along the banks of the Fox and Wabash rivers, where they spent hours exploring, observing, hunting, and collecting, often in company with Thomas Say. The forest there was unlike anything in Europe; it was the landscape the two men had come to America to see and to record. Both the writer and the artist delighted in the abundance of flora and fauna and the tangled density of primeval growth. Maximilian recorded the scene in several long passages in his diary, which Bodmer's paintings beautifully and accurately capture:

The banks [of the Wabash] *were overgrown with lofty, beautiful forest, in which tall sycamore trees with their broad branches gleamed snow-white in the densely entangled thicket. . . . After rowing 1/2 or 3/4 of an hour, we landed on the right bank and fastened our boat behind some thick, fallen trunks; then we climbed the steep bank of the river, which was already slippery because of the sun, and on top entered the tall forest, which had an undergrowth of cane eight to ten feet tall (with delicately feathered leaves,* Miegia macrocarpa). *This shoots up in a dense mass, but here is grazed by the cattle, which browse all around here day and night, and is penetrated by small paths. From the bank where we landed, it is several hundred paces across the island (called Fox Island), and then one finds oneself beside a sizeable stream with a strong current, called Fox River. . . . This stream is most scenic, with romantic banks, wildly toppled tall trunks, huge sycamores with white bark, magnificent oaks, hickory, shell-bark, etc.* Gymnocladus *with its large thick pods grows here,* [along with] *beautiful catalpas,* Bignonia radicans *and* cruicigera, *as well as enormous grapevines,* Rhus, Hedera quinquefolia *and* Smilax-species. . . . *In the water lie whole heaps of fallen timber, some of which, because of the low water-level, form what are almost crossings or bridges. . . . Here the huge sycamore trunks, which six to seven men cannot span, are noteworthy. They are often hollow, and a great number of men could find protection against the weather inside their trunks. At a height of twenty or thirty feet the trunks usually*

78 *The Wabash near New Harmony,* watercolor on paper.

fork into many huge branches, which rise to a great height and, covered with an almost dazzlingly white bark, shine in large number in the brownish-gray forest, stripped of its leaves by winter. All during the day this calm and quiet, lonely creek is visited by swarms of ducks.

Bodmer's paintings of the Fox and Wabash *[illus. 76 and 77]* illustrate many of the details recorded here: the giant, white trunked, hollowed-out sycamore trees with their spreading upper limbs, the last leaves clinging to the ends of their upper branches; the vines wrapped around and hanging from the trees; the falling and fallen trees littering the forest floor and obstructing the river; the sandbanks, clusters of willow, and reeds along the river banks; the ducks; and the cattle.

Although he continues to employ some of the conventions of landscape painting in composing the scenes – a cluster of trees on the right or left provides a foreground frame to the view, the curving river carries the eye into the background – the scenes are wild and exotic from a European point of view. The scientific purpose and activities of Maximilian's expedition placed a premium on accurate observation rather than picturesque composition or Romantic sanctification of the American landscape, and although Bodmer composes these views according to picturesque conventions, he achieves a level of realism not found in the work of Thomas Cole or Asher Durand.

The primeval forest environment of America was either cut down by pioneers as rapidly as possible or elevated by writers and painters, such as Cooper, Cole, and Durand, into a Romantic landscape embodying nationalistic, poetic, and religious ideals. Those who recorded it without such cultural lenses were relatively few. Bodmer's views of the Fox and Wabash go a step beyond the wild scene he painted at Mauch Chunk and appear guided by a desire to be faithful to the natural history of the place and time rather than by the intention of producing landscape art. Cole's forests, as vast and wild as they may seem, are always theatrically composed: a blasted tree trunk, like a ruin, frames the view in the foreground; a stream, road, or other element in the landscape leads the eye into the depths of the painting; light and shade are dramatically contrasted; and narrative elements often suggest a religious drama.

79 Asher Brown Durand, *In the Woods*, 1855, oil on canvas, The Metropolitan Museum of Art, Gift in memory of Jonathan Sturges by his children, 1895. © 1981/1995, by The Metropolitan Museum of Art, New York, New York.

The American artist of the period who comes closest to capturing the nature of the virgin American forest is Asher Durand. Durand's *In the Woods* of 1855, for example, portrays a dense forest of ancient trees with a vigorous undergrowth and a forest floor strewn with decaying trunks that have fallen naturally *[illus. 79]*. But the forest interior he has created is a sanctuary of divine creation. The trees over-arch with an openness and order that form a cathedral-like space. Windows of sky above and in the distance admit a religious light which gleams on the trunks of the standing and fallen trees. Durand's forest interior appears ancient, like the monuments of European architecture, not raw and chaotic like nature itself.

Bodmer's views of the Fox and Wabash, by contrast, present an impenetrable mass of foliage. Bodmer does not shape the forest into architecture or load it with religious reverberations. He does not sanctify it. As paintings, Bodmer's watercolors are less humanly comforting than Durand's. Their beauty is in their truthfulness to the environments from which Maximilian was collecting specimens.

This wild environment of the Fox and Wabash was not far from the civilized village of New Harmony, and Bodmer's depiction of the two places provide together a sense of the novelty of the American landscape of this period. In his account of traveling in America, de Tocqueville calls attention to such sudden transitions in the landscape from the wild to the civilized:

Just round a wood one sees the elegant spire of a clock tower, houses striking in their whiteness and cleanness, and shops. Two paces further on, the primeval and apparently impenetrable forest reclaims its dominion and again reflects its foliage in the waters of the lake.

Those who have passed through the United States will find in this picture a striking emblem of American society. Everything there is abrupt and unexpected; everywhere, extreme civilization borders and in some sense confronts nature left to run riot. That is something that one cannot conceive in France.[10]

Such sudden transitions are sometimes evident in Bodmer's visual journal in the contrast between his renderings of places not far distant from each other, such as the Wabash and New Harmony; sometimes in the contrast between elements within individual paintings. His view of Bethlehem, for example, depicts a prosperous town surrounded by well cultivated meadows and fields and bordered by a canal *[illus. 80]*. But the stump, partly decayed, and split-rail fence in the foreground remind the viewer of the frontier out of which this pastoral landscape has only recently been created. In his diary, Maximilian notes his dislike of the "stiff, unnatural character" of these fences, which epitomize for him the rough quality of the early stages of settlement. In Bodmer's painting of Bordentown *[illus. 66]*, the civilization embodied in the fashionably dressed people in the foreground and Joseph Bonaparte's Point Breeze estate in the background is juxtaposed to the heavily wooded shores of the Delaware and the raw landing.

The most recurrent images in Bodmer's eastern paintings are the rivers and canals that provided the arteries and veins of a growing civilization and the steamboats, keelboats, and rafts that provided the principal means of travel westward in the years before the railroad. This is a nation on the move: the canal next to the prosperous-looking city of Bethlehem; the landing at Bordentown, where community activity focuses on the arrival of the steamboat on the Delaware; the steamboat *Napoleon* taking on wood near Fort Adams on the Mississippi; even the faintly discernible raft or keelboat in the *Confluence of the Fox River and the Wabash* are all indications of a transformation in progress. As untamed and rural as Bodmer's landscapes mostly are, they often contain signs of the emerging, dynamic industrial society that would speed the process of settlement, and the destruction of the primeval forest and of Indian cultures and people.

The most common settlements on the frontier, of course, were not neat communities like Bethlehem, Economy, and New Harmony, which Bodmer paints admiringly, but the rough huts and cabins of pioneers, usually on land not yet fully cleared. Maximilian, like Frances Trollope, with whom he sometimes shares an aristocratic distaste for the crudeness of frontier manners and society, records in his diary the unfinished, ragged, dirty, and disordered nature of isolated frontier

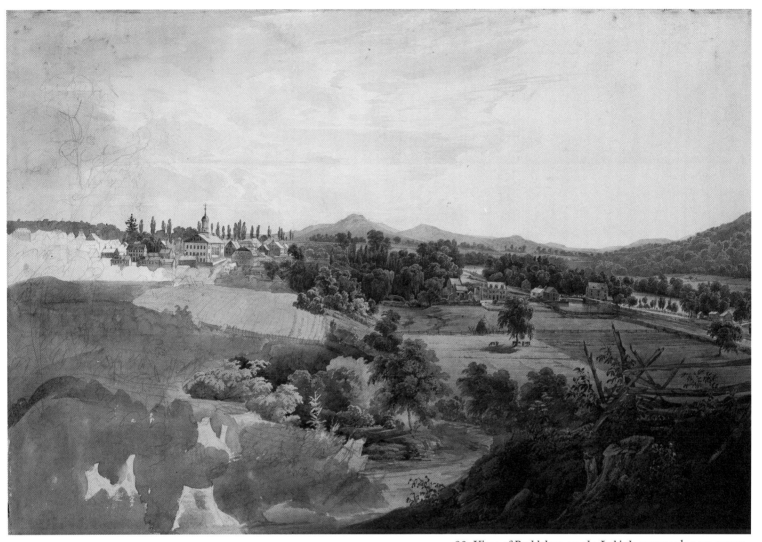

80 View of Bethlehem on the Lehigh, watercolor on paper.

81 Ohio-Mississippi River Keelboat, watercolor on paper.

82 Settler's Farm in Indiana, watercolor and pencil on paper.

dwellings, clearings, and settlements. Along the Ohio, for example, he sees "a small, poor settler's hut that stood open everywhere, built [so insubstantially that] the wind [whistled through]. A couple of miserable beds in it, the woman with a pipe in her mouth, busy with the fire, a pitiful wooden hearth. The man came [in] from the forest with one boy; both the other children looked pale and ailing."

In Bodmer's rare depictions of frontier structures *[illus. 82, 86, and 87]*, he does not romanticize them the way Thomas Cole does in *Home in the Woods* (1847) or Jasper Cropsey in *The Backwoods of America* (1858) *[illus. 83 and 84]*. His drawings and watercolors are straightforward, although there are few of the unpleasant details that Maximilian records.

For Maximilian, the raw frontier clearings and rude structures were evidence of the destructiveness of European settlement. Other writers and artists, such as Cooper and Cole, were intensely aware of the rapid destruction of the American forest and its inhabitants, but they often saw it as a grand drama, an inevitable and irreversible tragedy, the perception of which lent a kind of sublimity to the American landscape. Alexis de Tocqueville expressed this attitude eloquently when he wrote: "It is this consciousness of destruction, this *arrière-pensée* of quick and inevitable change that gives,

83 Thomas Cole, *Home in the Woods*, 1847, oil on canvas, Reynolda House,
Museum of American Art, Winston-Salem, North Carolina.

84 Jasper F. Cropsey, *The Backwoods of America*, 1858, oil on canvas, private collection.
(Photo courtesy Sotheby's, New York.)

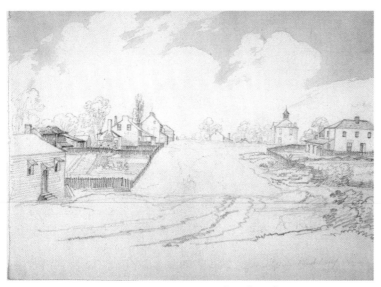

85 *Albion, Edwards County, Illinois*, pencil and wash on paper.

86 *Bon Pas on Green's Prairie*, pencil on paper.

we feel, so peculiar a character and such a touching beauty to the solitudes of America. One sees them with a melancholy pleasure; one is in some sort of hurry to admire them. Thoughts of the savage, natural grandeur that is going to come to an end, become mingled with splendid anticipations of the triumphant march of civilisation."[11] Maximilian and Bodmer did not share this "melancholy pleasure," this sense of magnificent doom and triumph, which permeates American landscape art from Cole's *Course of Empire* to Albert Bierstadt's *The Last of the Buffalo*. Maximilian, despite his clear appreciation of European civilization, of neat settlements and technology, was simply angry and blamed not only the wantonness of the settlers themselves but the United States government for not putting a stop to the reckless hunting, the unchecked cutting of trees, and the destruction of native peoples: "Thus the Indians have disappeared. Big game animals are so depleted that in ten years neither deer, wolves, nor wild turkeys will be found here. The elks, bears and beavers have already vanished; the remaining animals will follow very soon. The government should be severely reprimanded for failing to control these excesses."

Bodmer's paintings do not protest this destruction, but they express in another way what Maximilian valued most in America. They record the beauty of the European settlements that Maximilian admired: Bethlehem, Economy, New Harmony – all emblems of religious and political freedom and of community building rather than unrestrained individualistic settlement. They also celebrate the unspoiled natural landscapes which Maximilian recognized would soon be gone. Although undramatic, often pastoral in mood, and without the exotic subject matter of his paintings of Native Americans, Bodmer's eastern views provide a remarkable portrait of the area between the long-settled eastern seaboard and the upper Missouri frontier. With a realism unmatched by any other artist of the time, they show an expanding nation just on the verge of rapid agricultural, industrial, and urban development. Although the quality of this record owes much to the picturesque mode of depicting landscapes in which Bodmer was trained, it also reflects

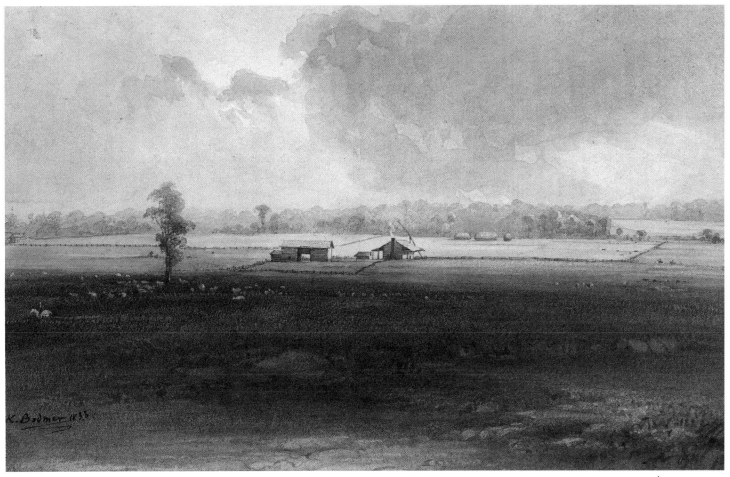

87 *View of a Farm on the Illinois Prairie*, watercolor on paper.

Bodmer's service to Maximilian's scientific purposes. Had he not been immersed with Maximilian in collecting and describing the flora and fauna of the eastern United States, Bodmer would not have produced such original images as his paintings of the wild forests of the Fox and Wabash rivers. It is also unlikely that he would have achieved the level of accuracy and straightforwardness that are the hallmarks of his work. Maximilian, who had himself produced undistinguished illustrations of his earlier expedition to Brazil, was fortunate in his choice of Bodmer, for Bodmer appears to have both grasped the artistic needs of the expedition and succeeded in fulfilling them. It is Bodmer's paintings rather than Maximilian's written accounts that provide the most vivid and enduring record of their journey.

John F. Sears is the Executive Director of the Franklin and Eleanor Roosevelt Institute in Hyde Park, N.Y. He received his Ph.D. in American Studies from Harvard and has taught at Tufts, Boston University, and Vassar College. He is the author of Sacred Places: American Tourist Attractions in the Nineteenth Century *(Oxford, 1989) and editor of the Penguin Classics edition of Henry James'* American Scene *(1995), among other works.*

[1] See *LaTrobe's View of America, 1795–1820,* eds. Edward C. Carter II, John C. Van Horne, and Charles E. Brownell (New Haven: Yale University Press, 1985).

[2] Paul Schach, "Maximilian, Prince of Wied (1782-1867): Reconsidered," *Great Plains Quarterly,* 14, no. 1 (Winter 1994): 8-9.

[3] Humboldt's *Cosmos* was published in English by H. G. Bohn, London, 1849-58.

[4] Maximilian, Schach notes, "was able to record Brazilian Indian languages so accurately that his observations have remained the unique basis for their classification." Schach, p. 12.

[5] All Maximilian quotations are drawn from one or both of the following sources at Joslyn Art Museum: Maximilian, Prince of Wied, *Tagebuch,* 1832-34, a three-volume manuscript diary; English phrasing from translations on file by William J. Orr, Paul Schach, and Emery C. Szmrecsanyi. Maximilian, Prince of Wied, *Travels in the Interior of North America, 1832-1834,* trans. H. Evans Lloyd (London: Ackermann & Co., 1843); annotated reprint by Reuben Gold Thwaites ed., in *Early Western Travels, 1748-1846,* vols XXII-XXIV (Cleveland: Arthur H. Clark Company, 1906).

[6] Charles Bonaparte appears to have stayed in touch with Maximilian, for he later would journey to Neuwied to view Maximilian's collections of flora and fauna that he had brought back from his North American expedition and make use of them in his *Conspectus generum avium* (Leiden: 1851-57). See Schach, p. 14.

[7] Patricia Tyson Stroud, *Thomas Say: New World Naturalist* (Philadelphia: University of Pennsylvania, 1992), p. 101.

[8] *Ibid.,* p. 161.

[9] Alexis de Tocqueville, *Journey to America,* ed. J.P. Mayer (New Haven: Yale University Press, 1960), pp. 323, 356. In his journal account of his trip to Lake Oneida, de Tocqueville remarks: "We plunge through an immense forest where the path is hardly traceable. Delicious freshness that reigns there. Sight wonderful and impossible to describe. Astonishing vegetation. Enormous trees of all species. Mass of foliage, grasses, plants, bushes. America in all her glory, waters (?) running on every side, huge pines uprooted by the wind, twisted among plants of every sort." *Journey to America,* p. 130.

[10] *Ibid.,* p. 332.

[11] *Ibid.,* p. 372. In his "Essay on American Scenery" of 1835, Thomas Cole wrote elegiacally: "And to this cultivated state our western world is fast approaching; but nature is still predominant, and there are those who regret that with the improvements of cultivation the sublimity of the wilderness should pass away: for those scenes of solitude from which the hand of nature has never been lifted, affect the mind with a more deep toned emotion than aught which the hand of man has touched." Rpt. John Conron, *The American Landscape: A Critical Anthology of Prose and Poetry* (New York: Oxford University Press, 1973), p. 571.

All artworks, documents, and other archival material are from the collection of Joslyn Art Museum, Gift of the Enron Art Foundation, unless otherwise noted.

ARTWORKS

All artworks are listed alphabetically by title within categories: *Watercolors and Drawings by Karl Bodmer; Aquatints After Karl Bodmer;* and *Other Artists.* Dimensions are in inches; height precedes width.

WATERCOLORS AND DRAWINGS BY KARL BODMER (1809-1893)

Albion, Edwards County, Illinois
pencil and wash on paper
6 3/8 x 8 3/4 *[illus. 85]*

Backwoods Man and Woman on Horseback
pencil on paper
6 3/8 x 8 5/8 *[illus. 23]*

Baton Rouge on the Mississippi
pencil on paper
6 3/8 x 8 5/8 *[illus. 38]*

Bear Trap
pencil on paper
4 1/8 x 5 7/16 *[illus. 9]*

Billie, a Choctaw Man
watercolor over pencil on paper
8 11/16 x 6 3/8 *[illus. 32]*

Bon Pas on Green's Prairie
pencil on paper
6 1/4 x 8 5/8 *[illus. 86]*

Boston Lighthouse
watercolor on paper
6 3/8 x 8 5/8 *[illus. 4]*

The Brig Janus
pencil on paper
12 x 16 3/4 *[illus. 3]*

The Bunker Hill Monument
ink and wash on paper
6 3/8 x 8 5/8 *[illus. 6]*

Choctaw Camp on the Mississippi
watercolor over pencil on paper
6 3/8 x 8 3/4 *[illus. 40]*

Choctaws at Natchez
watercolor and pencil on paper
8 3/4 x 6 3/8 *[illus. 42]*

Choctaws at New Orleans
watercolor over pencil on paper
8 3/4 x 6 3/8 *[illus. 35]*

Church at Baton Rouge
watercolor and pencil on paper
6 3/8 x 8 5/8 *[illus. 36]*

Confluence of the Fox River and the Wabash
watercolor on paper
11 7/8 x 14 1/2 *[illus. 24 and 76]*

Cotton Boat near Baton Rouge: The Lioness
watercolor on paper
6 3/8 x 8 5/8 *[illus. 39]*

Courthouse at Mount Vernon
watercolor on paper
6 3/8 x 8 3/4 *[illus. 44]*

Deck Plan of the Steamboat Homer
watercolor and pencil on paper
6 3/8 x 8 5/8 *[illus. 28]*

The Delaware Water Gap
watercolor on paper
9 5/8 x 14 1/2 *[illus. 10]*

Economy, Rapp's Colony on the Ohio
watercolor on paper
10 3/4 x 17 *[illus. 58]*

Entry to the Bay of New York from Staten Island
watercolor and pencil on paper
11 7/8 x 16 7/8 *[illus. 7]*

A Female Bullfrog
watercolor over pencil on paper
6 3/8 x 8 *[illus. 71]*

Fort Adams on the Mississippi
watercolor on paper
6 3/8 x 8 5/8 *[illus. 31]*

The Fox River near New Harmony
watercolor on paper
11 7/8 x 14 1/2 *[illus. 77]*

Gentlemen at Louisville
pencil on paper
6 3/8 x 8 5/8 *[illus. 20]*

Gnadenhutten
watercolor on paper
8 1/2 x 11 7/8 *[illus. 13]*

Grave of the Brethren at Gnadenhutten
watercolor and pencil on paper
8 1/2 x 11 7/8 *[illus. 14]*

Lesueur, the Naturalist at New Harmony
watercolor on paper
6 3/8 x 10 1/2 *[illus. 70]*

Lighthouse near Natchez on the Mississippi
watercolor and pencil on paper
8 1/2 x 6 3/8 *[illus. 27]*

Mahoning Creek, Pennsylvania
watercolor and pencil on paper
9 5/8 x 14 1/2 *[illus. 67]*

Manor House of Joseph Bonaparte near Bordentown
watercolor on paper
6 3/8 x 8 3/4 *[illus. 59]*

The Mauch Chunk Canal: Woehler's Inn
watercolor on paper
11 3/4 x 16 7/8 *[illus. 8]*

Military Barracks at Baton Rouge
watercolor on paper
6 3/8 x 8 5/8 *[illus. 37]*

*The Mississippi near
Ste. Geneviève*
watercolor on paper
6 3/4 x 7 5/8 *[illus. 45]*

New Harmony, Indiana
watercolor on paper
7 5/8 x 9 3/4 *[illus. 22]*

New Mexico on the Mississippi
watercolor on paper
6 3/8 x 8 3/4 *[illus. 29]*

Ohio–Mississippi River Keelboat
watercolor on paper
5 7/8 x 8 1/2 *[illus. 81]*

Ohio River near Rome
watercolor on paper
6 3/8 x 8 3/4 *[illus. 18]*

Portland on the Ohio
watercolor on paper
6 3/8 x 8 5/8 *[illus. 19]*

*Prehistoric Indian Mounds
opposite St. Louis*
ink over pencil on paper
10 7/8 x 16 3/8 *[illus. 51]*

The Prison in Pittsburgh
watercolor and pencil on paper
11 7/8 x 16 7/8 *[illus. 61]*

Rockport on the Ohio
watercolor on paper
6 3/8 x 8 1/2 *[illus. 17]*

Salamander
watercolor on paper
7 1/8 x 10 *[illus. 72]*

Scene on the Janus
watercolor and pencil on paper
5 1/2 x 8 *[illus. 2]*

Settler's Farm in Indiana
watercolor and pencil on paper
11 3/4 x 17 *[illus. 82]*

Shot Tower below Herculaneum
pencil on paper
4 3/4 x 8 *[illus. 48]*

Shot Tower near Herculaneum
watercolor and pencil on paper
4 7/8 x 7 1/8 *[illus. 49]*

Shot Tower near Selma
pencil on paper
4 7/8 x 7 7/8 *[illus. 47]*

The Steamboat Napoleon
watercolor and pencil on paper
6 3/8 x 8 5/8 *[illus. 63]*

*Susquehanna near Harrisburg,
Pennsylvania*
watercolor on paper
6 1/4 x 8 5/8 *[illus. 15]*

Telegraph Hill, Boston
watercolor on paper
6 3/8 x 8 5/8 *[illus. 5]*

Trappists Hill opposite St. Louis
pencil and ink on paper
10 x 12 1/2 *[illus. 50]*

Tshanny, a Choctaw Man
watercolor and pencil on paper
8 5/8 x 6 3/8 *[illus. 34]*

Tsholocha, a Cherokee Man
watercolor over pencil on paper
8 5/8 x 6 3/8 *[illus. 41]*

Tulope, a Choctaw Man
watercolor over pencil on paper
8 5/8 x 6 3/8 *[illus. 33]*

A Turtle
watercolor on paper
8 x 10 *[illus. 73]*

View of Bethlehem on the Lehigh
watercolor on paper
11 7/8 x 17 1/4 *[illus. 80]*

*View of a Farm on the Illinois
Prairie*
watercolor on paper
5 1/4 x 8 3/8 *[illus. 87]*

*View of Mauch Chunk,
Pennsylvania, with Railroad*
watercolor on paper
11 7/8 x 17 *[illus. 74]*

View of New Harmony
watercolor on paper
6 1/4 x 10 3/4 *[illus. 21]*

View of Niagara Falls
watercolor on paper
12 1/4 x 20 *[illus. 54]*

View of Pittsburgh
watercolor and pencil on paper
11 7/8 x 17 *[illus. 16]*

*View on the Delaware: Joseph
Bonaparte's Garden*
watercolor on paper
6 3/4 x 10 1/8 *[illus. 66]*

*View on the Delaware near
Bordentown*
watercolor on paper
11 3/4 x 16 3/4 *[illus. 65]*

View on the Mississippi
watercolor on paper
6 3/8 x 8 5/8 *[illus. 26]*

Vincennes, Indiana
watercolor on paper
10 x 12 3/4 *[illus. 52]*

The Wabash near New Harmony
watercolor on paper
14 1/2 x 11 7/8 *[illus. 78]*

AQUATINTS AFTER
KARL BODMER

Cave-in-Rock, View on the Ohio
engraving with aquatint,
hand-colored
10 3/8 x 13 7/8 *[illus. 64]*

*Cleveland Lighthouse on
the Lake Erie*
engraving with aquatint,
hand-colored
10 1/2 x 13 1/2 *[illus.53]*

*Forest Scene on the Lehigh
(Pennsylvania)*
engraving with aquatint,
hand-colored
16 x 21 *[illus. 75]*

*Forest Scene on the Tobihanna,
Alleghany Mountains*
engraving with aquatint,
hand-colored
9 1/4 x 12 1/2 *[illus. 11]*

New Harmony on the Wabash
engraving with aquatint,
hand-colored
16 1/4 x 21 1/2 *[illus. no. 68]*

Niagara Falls
engraving with aquatint,
hand-colored
16 1/4 x 21 1/2 *[illus. 55]*

Penitentiary near Pittsburgh
engraving with aquatint,
hand-colored
9 7/8 x 13 3/4
Museum Purchase
[illus. 60]

*Tower-Rock, view on the
Mississippi*
engraving with aquatint,
hand-colored
10 3/4 x 14 *[illus. 46]*

OTHER ARTISTS

Henry Hoppner Meyer
(English, 1783-1847)
*Portrait of Thomas Say,
1787-1834*, 1839,
steel engraving, 9 x 6 1/2, after
a painting by Joseph Wood
(American, 1778-1830)
[illus. 69]

DOCUMENTS AND OTHER ARCHIVAL MATERIAL

MANUSCRIPT MANUAL

Tagebuch (Journal), volume I of Maximilian's three-volume account of his travels in North America in 1832-1834. *[illus. 12]*

Contract between Maximilian and Karl Bodmer for Bodmer's services, April 20, 1832.

PRINTED MATERIAL

Map of the States of Ohio, Indiana, Illinois and part of Michigan Territory, Philadelphia: S. Augustus Mitchell, 1831.

Broadside advertisement for the Ohio and Mississippi steamboat *Homer,* 1832.

Fare summary, "A List of Towns and Principal Landing Places" between Louisville and New Orleans, n.d.

Broadside advertisement, *Falls of Niagara,* 1834.

Broadside advertisement, *Philadelphia and Mauch Chunk Line of Post Coaches,* 1832. *[illus. 62]*

Broadside advertisement for sale of plantation, slaves, and equipment, New Orleans, January 11, 1833. *[illus. 30]*

Broadside announcement, *Cure of Cholera,* 1832.

Book, *The Tourist, or Pocket Manual for Travellers,* New York: Harper and Brothers, 1834.

A Catalogue of Drugs, . . . and Miscellaneous Articles connected with the Drug Business, from the Philadelphia firm of W. & L. Krumbhaar, n.d.

Advertisement/product listing for R. H. Hobson, "Fancy Stationer, Music & Printseller," n.d.

Card advertisement, *Young Ladies Seminary at Bethlehem Pennsylvania,* n.d.

Bill for supplies, Place & Souillard, Apothecaries & Chemists, New York, July 11, 1832.

Bill for board and lodging, Franklin House, Providence, July 8, 1832.

Bill for board and lodging, Dr. Henry Woehler, Bethlehem, September 15, 1832.

Bill for board and lodging, Exchange Hotel, Pittsburgh, 1832.

Bills (3) for board and lodging, Eagle Hotel, Niagara Falls, New York, July 1, 1834.

Invitation to a Ball at the New Harmony Hotel, New Harmony, November 6, 1832

Invitation to a Celebration Ball at the Lafayette Hotel, New Harmony, February 22, 1833.

Electoral ticket for the presidential election (Henry Clay, President; John Sergeant, Vice-President), 1832.

ILLUSTRATED ARTWORKS NOT IN THE EXHIBITION

after Karl Bodmer (Swiss, 1809-1893)
Cutoff-River, Branch of the Wabash
engraving with aquatint, hand-colored, 9 1/4 x 13
[illus. 25]

after Karl Bodmer (Swiss, 1809-1893)
The Travellers Meeting with Minatarre [Hidatsa]
Indians near Fort Clark
engraving with aquatint, hand-colored, 11 1/4 x 13 3/4
[illus. 1]

Thomas Cole (American, 1801-1848)
Home in the Woods, 1847
oil on canvas, 44 x 66
Reynolda House, Museum of American Art, Winston-Salem, North Carolina
[illus. 83]

Jasper F. Cropsey (American, 1823-1900)
The Backwoods of America, 1858
oil on canvas, 42 x 70 1/4
Private collection
[illus. 84]

Loys Delteil (French, 1869-1927)
Karl Bodmer, 1809–1893, 1894
engraving, 3 7/8 x 5 3/8
[illus. 56]

Asher Brown Durand (American, 1796-1886)
In the Woods, 1855
oil on canvas, 60 3/4 x 48
The Metropolitan Museum of Art, Gift in memory of Jonathan
Sturges by his children, 1895. ©1981/1995, by The
Metropolitan Museum of Art, New York, New York
[illus. 79]

Benjamin Henry LaTrobe (American, 1764-1820)
Road From Newark to Patterson, N.J., 1880
watercolor on paper, 8 3/8 x 18 11/16
Maryland Historical Society, Baltimore, Maryland
[illus. 57]

Charles-Alexandre Lesueur (French, 1778-1846)
Chaktaw Indianer, 1830-32
pencil on paper, 7 1/2 x 10 5/8
[illus. 43]